A Journey Through the

CHILTERN HILLS

DR JILL EYERS
& HAYLEY WATKINS

AMBERLEY

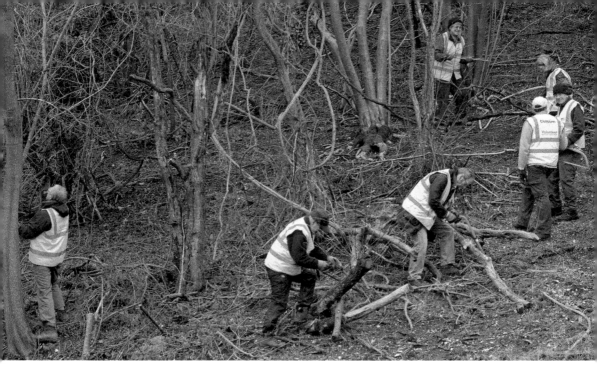

A volunteer team from The Chiltern Society carrying out vital maintenance and coppicing work on Brush Hill.

Acknowledgements

Many thanks for the helpful advice and photographs provided by John Morris, Stuart King, Katy Dunn, Jeremy Young and Alison Jewsbury, and for permission to use the Chilterns AONB map from the Chilterns Conservation Board archive.

First published 2014

Amberley Publishing
The Hill, Stroud, Gloucestershire, GL5 4EP
www.amberley-books.com

Copyright © Dr Jill Eyers & Hayley Watkins, 2014

The right of Dr Jill Eyers & Hayley Watkins to be identified as the Author of this work has been asserted in accordance with the Copyrights, Designs and Patents Act 1988.

ISBN 978 1 4456 3624 5 (print)
ISBN 978 1 4456 3652 8 (ebook)

British Library Cataloguing in Publication Data.
A catalogue record for this book is available from the British Library.

Typesetting by Amberley Publishing.
Printed in Great Britain.

Contents

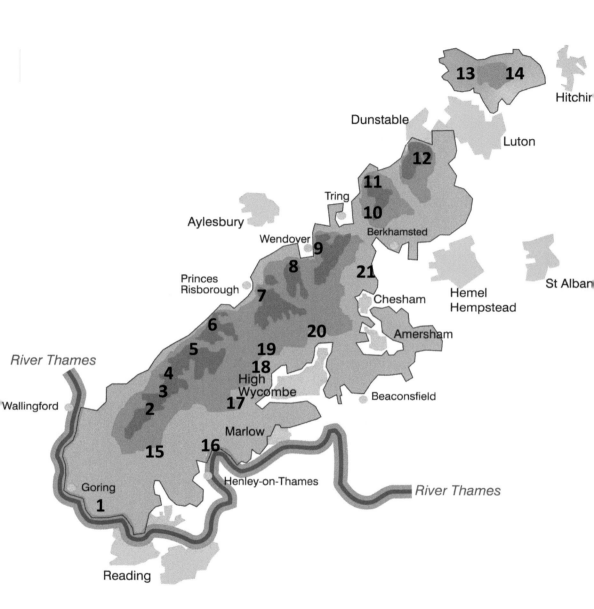

Above: Map of the Chilterns Area of Outstanding Natural Beauty (AONB) showing the twenty-one locations for the trails exploring the Chiltern Hills. (*Map courtesy of the Chilterns Conservation Board*)

Right: Hughenden Valley: Green, rolling hills, red-tiled roofs and a patchwork of fields with their boundaries in place since the Bronze Age 4,500 years ago. (*Photograph by Hayley Watkins*)

Introduction

The entire 833 square kilometres of the Chiltern Hills crosses five counties: Bedfordshire, Hertfordshire, Buckinghamshire, Berkshire and Oxfordshire. It is a natural area incorporating a great variety of habitats including chalk grassland, woodland and scrub, river valleys and chalk streams, it also includes 213 commons, many heaths and large areas of farmland. It is a beautiful area with a unique landscape and natural history, which is recognised throughout the UK – hence the area is protected as an Area of Outstanding Natural Beauty. It is amazing to think that the centre of the Chilterns is only 35 miles from Trafalgar Square in London.

This book will guide the reader on a journey through the Chilterns. The journey may be started from one of the railway stations nearby the journey locations, or selected sites may be reached by car. A treat is in store for walkers, as many of the paths are ancient tracks including Britain's oldest road, the Ridgeway. Having arrived in the Chiltern Hills, the selected journey may take you through time from viewing Ice Age mammoths to Iron Age hill forts or Roman villas. Maybe some Norman churches, Tudor houses or Victorian schools with interesting 'extras' will also tempt some visitors. The journey will certainly lead you through woodland (which covers one-fifth of the Chilterns) and along dry valleys and chalk streams nestled in the green, rolling hills.

Underlying the landscape is, of course, the geology – the character of the rocks beneath the surface and the history they have undergone is fascinating. This is where our journey must start – with an explanation of how the Chiltern Hills have formed – as rocks make landscape.

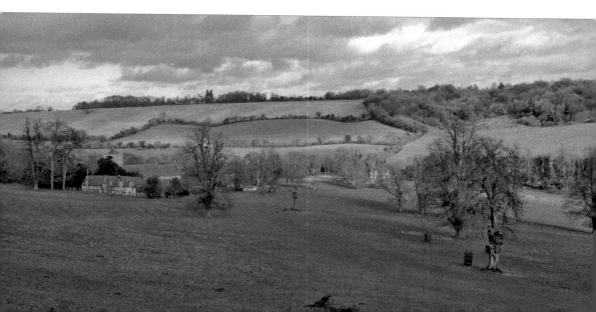

Making the Chiltern Hills:
From the Greenhouse to the Freezer

Geologically, the Chilterns' story starts around 100 million years ago with a massive global warming accompanied by a sea level rise of more than 300 metres. As a direct result of this event, Britain became the centre of a very large sea, as more and more land became flooded. In fact, the whole of what is now Europe was so far from land that sediment (as silt and sand eroded and transported by rivers) could never reach it. However, the warm temperatures and large expanse of ocean was perfect for marine life. Masses of tiny calcareous plankton, notably coccoliths, rained to the sea floor, eventually building up hundreds of metres of chalky ooze. Thousands of these tiny skeletons would fit on a pinhead, yet they make up the backbone of the entire Chilterns (and the North and South Downs too).

Eventually, 65 million years ago, the climate returned to normal, the seas receded and large areas of white, oozy sea floor were exposed as land. This was a very flat landscape – no hills had been formed as yet. For millions of years, this remained exposed as a flat, featureless land. However, several important events began to occur from 65 to 50 million years ago, starting with the ooze becoming hard chalk. Africa bumped into Europe, which gave the Chilterns chalk a little tilt of a few degrees (although small, this is the reason for the escarpment today). Add to this scenario the effect of constant rain and flowing groundwater, which gradually dissolved the chalk and left a residue on the top (called Clay-with-flints, which still caps many high points of the hills). The waterlogged land gradually formed a thick sequence of ancient soils (palaeosols), which were later exploited as brick-making clays (called the Reading Formation). Subsequent estuary and river action can be seen as collections of sand and mud at several sites on the walks. The Chilterns even saw the return of the sea for a brief while 40 million years ago – evidence is in the form of the London Clay capping a few hilltops.

Gradually, many hundreds of metres of chalk were dissolved and topped by layers of clay, sand and cobble beds. The hills and valleys we see today still had not formed by half a million years ago. The rounded hills and deeply dissected dry valleys, which we think of as so distinctive of the ancient Chilterns area, are actually a very young feature. The Chilterns landscape is a mere youngster, and is the result of the processes active during the Ice Age. Although the Ice Age started around 2.6 million years ago, the main shaping of the Chilterns landscape only occurred during the last half a million years.

The Ice Age was a crucial time for shaping landscape throughout the UK. During that time the climate changed many times, alternating between cold glacial conditions and warmer interglacial environments. While in the grip of the ice, the Chilterns experienced frozen ground and became tundra. On at least three occasions, the hills witnessed the advance of ice sheets down the vales beneath. The coldest glaciation was during the Anglian period of half a million years ago, when a 2-km-thick ice sheet ground its way southwards down the vales of Marston

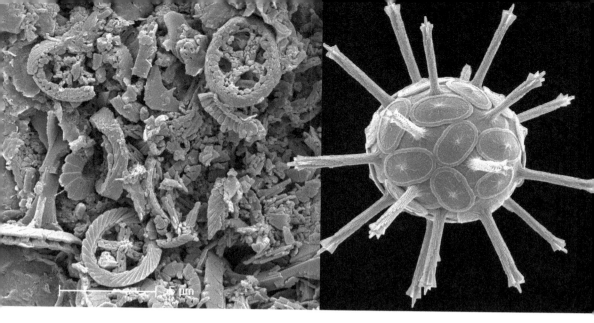

Above: Coccoliths are the calcareous plates that form a sphere around tiny algae and their bodies make up most of the chalk. (*Coccoliths by Jeremy Young*)

Right: A woolly mammoth, part of the Chiltern's wildlife until the end of the Ice Age 10,000 years ago. (*Photograph by Hayley Watkins*)

Below: A chalk exposure in Bucks. (*Photograph by Jill Eyers*)

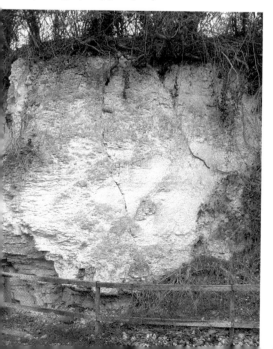

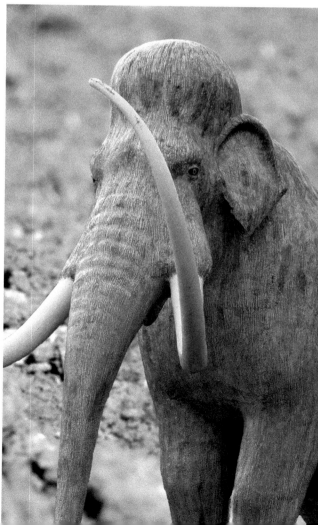

and Aylesbury. It eroded and shaped the landscape as it went, and deposited distinctive sediment called 'Till'. Did this ice sheet cover any part of the Chiltern Hills? Geologists would love to know, but the evidence has never been found and is currently a topic of hot debate (excuse the pun).

However, the effects of the tundra and the melting of snow at the end of each cold phase can easily be seen today in all the river valleys and dry valleys of the Chilterns. Animals walking the hills at the end of the Ice Age included mammoth, woolly rhinoceros and bison, among many others.

The warmest phases, known as interglacials, brought with them the temperatures and animals more suited to the African plains. For instance, during the warm phase seen at College Lake, Marsworth (*Trail 11*), 120,000 years ago there were straight-tusked elephants, forest rhinoceros and lions walking the landscape!

Above: View of the chalk scarp from Aston Rowant showing the old Chinnor Cement Works at the base of the slope where the soft calcareous clay called Lower Chalk was extracted for industry. (*Photograph by Jill Eyers*)

Opposite: A reconstruction of what the Roman Yewden villa in the Hambleden Valley would have looked like in the third century AD. A 'villa' was just a working farm, but the name has come to mean the high-status kind, which is large and full of mosaic floors. The vast majority were much simpler buildings, especially in the Chilterns, where the building would be in local materials of wood and wattle and daub, with flint and chalk rock sometimes being used. Early roofing was often thatch, but tiles made from local clays were used also. (*Reconstruction by Alison Jewsbury*)

People in the Landscape

The name 'Chilterns' is derived from the Celtic word *Cilterne*, meaning 'land beyond the hills'. The hills were used for hunter-gathering from the Stone Age onwards, and people migrated in and out of England with the cycles of alternating advances or retreats of the ice. Where were these people heading as they crossed the Chilterns, and how did they navigate the dense woodland of the interglacial environment? The Chilterns became a good source of wood and food. Later, from Neolithic time onwards (6,500 years ago), people settled and began using the landscape for grazing animals and other purposes, such as communal burials. These were the first farmers, discovering how to grow crops and rear animals along the way. This progressed seamlessly into the managed landscape of the Bronze Age 'cowboys' from 4,500 to 2,500 years ago. Cattle rearing became a mainstay of farming at the end of the Bronze Age as excessive rainfall during this period lead to many years of crop failure. The field boundaries put in place during this time (which held the cattle) form the basis of the field systems still in use by farmers today. The need for ample land for cattle rearing and enclosing areas of

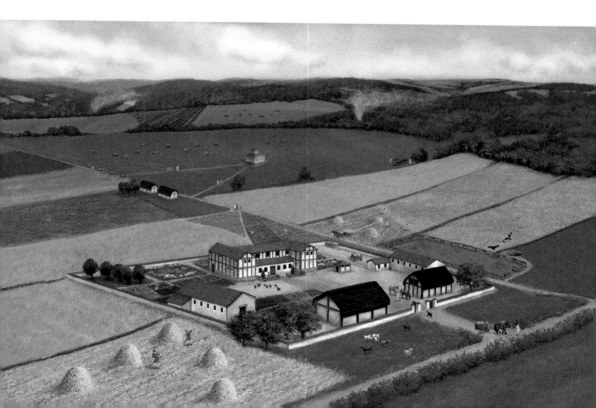

ownership, plus a growing population, ultimately led to the conflicts and battles of the Iron Age tribes from 800 BC. Many Iron Age villages and hill forts feature in this book's journeys, and several have intriguing stories. Iron Age people held very strange beliefs and customs – but many of them still lurk in our lives today. Many of the Chilterns residents remain totally unaware that they still harbour Iron Age beliefs – which amount to every superstition and the many 'rituals' we still have such, as mistletoe at Christmas or throwing a coin in a fountain. These are explained at various points in the book.

As Britain came under Roman rule, the locals fell under the spell of the monetary system and aspired to own new-style housing, such as villas with central heating and baths. A lasting legacy was the vast array of introduced foods, which provided new, wonderful flavours from fruits (such as apples, cherries or plums), vegetables (such as carrots and broad beans), herbs (such sage, mint and chives) along with a whole host of others, including a good variety of spices, none of which had been seen in the British diet before. This led to new crop introductions that have stayed in our farmed landscapes to the present day. The original Iron Age tribe of the Chilterns – the *Catuvellauni* – became collaborators and facilitated the Roman army moving through to other parts of the country. The villa system that rapidly developed is well displayed by a prolific abundance of these working farms throughout the Chiltern valleys. However, the locals themselves, the Romano-British, kept many of their traditions, despite Roman laws forbidding them. The Chiltern natives truly were revolting!

However, the Chiltern Hills were not always thought of as the beautiful place perceived today. In Anglo-Saxon times, the area is recorded as being lived in by the *Cilternsætan* and it was described as a 'god-forsaken place that no one in their right minds would want to settle'. But settle they did, and settlements bearing Anglo-Saxon names, such as Goring, Bledlow, Wycombe, Chesham and Luton, all testify to the many groups of people living, farming, burying and trading in the region. Hidden in the landscape are also Viking names, such as Fingest and Frieth – where did they sneak in from? Such massive stories in little names, as this book will reveal.

Next in the timeline, the Normans made their mark by reshaping boundaries and ownership. Monasteries were given large swathes of land, with locals virtually or actually in slave labour. Churches were built and elegant sculptures brought into the area. Monasteries were financially well supported throughout this time and, as they became huge landowners, their mark is still imprinted on the landscape (*see an example in Trail 7, Monks Risborough*).

Livelihoods in the Chilterns

People have been living in the Chilterns since the Lower Palaeolithic time, at least 400,000 years ago. Discarded or lost stone tools are evidence for their presence and the tool manufacture on site is seen as the debris on working floors. Their living was by hunter-gathering and this continued until we settled as farmers in the Neolithic period, around 6,500 years ago. At this time, we not only grew arable crops but practiced animal husbandry, plus we started digging mine shafts to reach layers of quality flint from within the chalk (Pitstone Hill near Ivinghoe is one such example).

Agriculture has always been an important livelihood of the Chilterns, as it still is today. However, the soils lying directly over chalk are very poor in nutrients, and they are also very dry. As a result, the tops of the hills have always been traditionally used for grazing sheep since

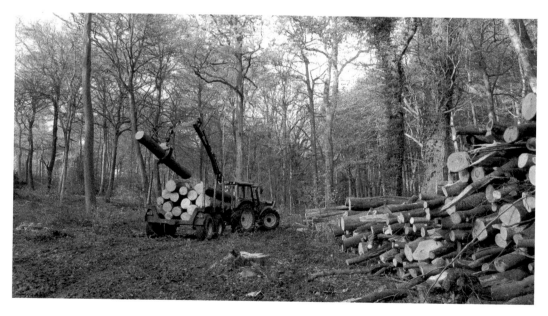

Chiltern woodland management today. Managing our woodland is what makes it unique, with a multitude of species providing a diverse habitat. In the past, management was by coppicing (cutting branches low down to collect firewood) or pollarding (cutting high if animals are a problem in eating new growth). Charcoal and firewood became a big industry with regular shipments to London from the Roman period onwards. Larger whole trees, notably oak, were harvested for a multitude of purposes – famously for shipbuilding, but also quality house beams. Furniture from the beech woodland became famous as bodgers crafted their wares skilfully in the woods to sell on to the furniture industry. (*Photograph by John Morris*)

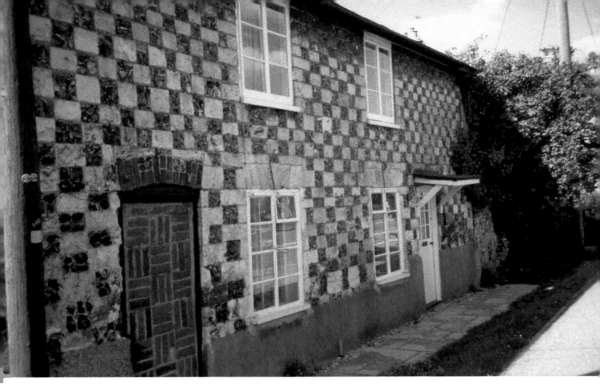

The chequerboard cottage style of building, using local materials, which is so characteristic of older buildings in the Chilterns. It can be found in houses and churches, and other patterns are just as common. (*Photograph by Jill Eyers*)

the earliest farmers more than 6,000 years ago. Where the hilltops are covered in clay (such as Clay-with-flints), then this is where woodland flourishes – these areas have always been managed for wood products, and in the past the place for keeping pigs (*as in Swyncombe Trail 2*). In contrast, the soils within the dry valleys are often more arable and can sustain crops, especially where the water table intersects the surface and a chalk stream merges. Water meadows and ancient field systems are common features in these locations – such as the Chess Valley.

Livelihoods linked to agriculture include a wide variety of products, including the famous Bucks 'prune', which were actually cherry trees. It is recorded that more than 2 tons of cherries were harvested from Stoke Row village in Oxfordshire each day alone – and the orchards throughout Bucks were famous for their quality and quantity also. Other industries include straw plaits (for hats) made from the wheat stalks, and watercress beds. Watercress from the Chilterns became a large industry, and these beds were to be found in many villages where streams kept a steady flow from springs within the valleys. The water is filtered by the chalk and contains all the natural nutrients and minerals that the watercress requires to grow. Watercress was harvested early in the morning while temperatures were still cool and sold the same day. Traditionally, this was a very labour-intensive business. There is a nature area on the site of the watercress bed in Ewelme, and two watercress beds in the Mimram Valley are still producing today. The Victorians, who stimulated the original trade, thought of watercress as we do – as a 'superfood'.

Quarries and numerous small pits were dug all over the Chilterns. The largest extraction sites are without doubt the more recent quarries for the extraction of Lower Chalk for the

cement industry (Kensworth, Pitstone and Chinnor being good examples). These quarries are all located at the foot of the scarp where the clayey chalk is to be found. Many large-scale workings in woodland were extracting clay for the brick and tile kilns. These are to be found over the Reading Beds clays. These range from very large operations, such as the continuing operations in Chesham by H. G. Matthews, to the older excavations going back to the thirteenth century – extraction for quality floor tiles at nearby Leyhill or at Penn & Tylers Green for instance. Smaller pits were to source a multitude of resources, such as sand, gravels or chalk. Deep pits (shafts up to 10 metres) were often dug in the same area where clay was extracted for the brick kilns. It seems that this was often a sideline income, and was either for agricultural use or using the kilns for lime production. The chalk was collected in baskets by a pulley and windlass system. A legacy of these eighteenth- and nineteenth-century shafts, often with tunnels running from a central bell pit, is that they are prone to collapse. As they were not recorded and only hastily covered over rather than backfilled, this will be a continuing hazard to the unwary builder in these areas.

In our archaeological past, building materials were usually those found close at hand. Exceptions might be for prestigious buildings, such as churches or royal residences. The Chilterns' most popular building material was without doubt wood. However, building stone does occur in the Chilterns and include chalk rock, Totternhoe Stone, flint and sarsen. The latter two can be sourced loose at the surface or could be dug out from shallow pits. A popular building style in the Chilterns is the 'chequerboard' pattern, created by alternating chalk rock, or other hard chalk bed, with knapped flint.

Commons and heaths played a vital role in the economy in the past, although today they mostly function as leisure or nature localities. They are nearly always in areas of less fertile or waterlogged soil. This means they are nearly always found on geology such as bare chalk, Reading Beds clays or Ice Age sand and gravels. Sometimes, a clay layer underlying sands or gravels provided a perched water table and hence these sites could be used for grazing. This was also the case where small-scale extraction had left pits and hollows that could fill with water. These were used for livestock in the past, but provide valuable ecological havens for wildlife today. As these areas were also the locations for brick, tile and pottery production, as well as collecting firewood, gravel and chalk extraction, the past environment would have been very different. These commons and heaths were traditionally dirty, industrial areas where poor people lived. Today, they are highly sought after for homes. A significant change in the Chilterns landscape occurred after the rural and arable decline from around 1875 to 1940, with the loss of many pastures and commons. Scrub and woodland recolonised what had previously been used as downland at this point, and the result is much woodland only that is around sixty to 100 years old but is well-developed.

Hopefully, this short introduction has provided the flavour of the content of the book. Now it is up to the reader to explore the delights of the beautiful present-day landscape, and to sample the localities to see how the blending of the geological, archaeological, historical and ecological layers all interweave and create the unique character of every hillside, wood, town and village of the Chilterns. To add spice to this layer cake, there is a good sprinkling of mystery, legend and intrigue at several sites.

CHILTERN TRAILS:
THE CHILTERN ESCARPMENT

The Chilterns, as the higher ground emerging from the low-lying vales separated by a steep scarp edge, have remained a distinctly separate region throughout its entire history. The early records name it as the 'place of the Chiltern dwellers' or *Cilternsætan*. Walter de Henley, an agricultural writer of the thirteenth century, separated out the area as the 'Chilterne land'. Robert Plot, who wrote the *Natural History of Oxfordshire* in 1677, described the area as 'Chiltern country'. Therefore, the area was quite distinct to these writers from an agricultural and natural history viewpoint. To see what is unique about these relatively small hills, a journey to the Chilterns is required and the following trail points will provide a little indication of what the region has to offer. The original place names are provided for each location, along with who named them, which will indicate what the area offered at that point in time.

1

Goring to Hartslock

A Journey from Gara's People to the Deer Keeper's Place

[From the personal name Gara and *ingas* meaning 'people of', and Old English *heorot* (a hart or deer) and *lōcere* (a gamekeeper/shepherd). There is an alternative view for the name Hartslock, which is, the 'Hurt family's locked gate'. However, the author believes the first suggestion is the correct one.]

The River Thames at the point it shallows between Goring and Streatley has always been an important crossing point. The name Streatley comes from *strāt* (meaning street) and *leāh* (meaning a clearing). Specifically, the Anglo-Saxon naming of this site refers to the clearing made for the Roman road that crossed here as a major route from Dorchester-on-Thames to Silchester, both vital market towns and major settlements.

Both Goring centre and the river walk are full of interesting buildings and features. A convenient place to park is the pay and display car park next to the Catherine Wheel pub. A route map may be found by searching the web for downloadable leaflets (e.g. the Bucks Earth Heritage Group

Above: View of the River Thames at Goring. The bank rises steeply on the other side – evidence of a rapid down-cutting of the channel during a glacial period in the Ice Age. (*Photograph by Jill Eyers*)

Below: The Catherine Wheel, the oldest pub in Goring. (*Photograph by Jill Eyers*)

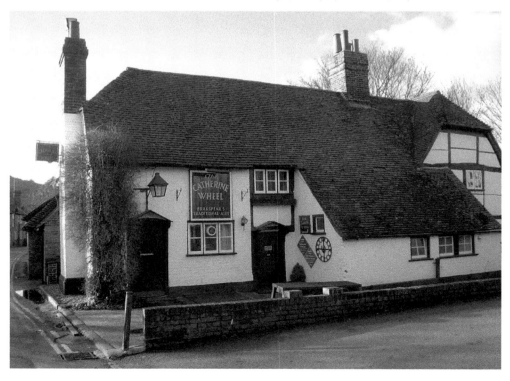

website). This could be a circular route or simply retrace your steps to keep by the picturesque riverside, ignoring the Gatehampton Road to get back to the river. From the Catherine Wheel, direct access to the river is from the bridge at the end of the High Street. Whichever way your journey takes you, a wander around will encounter the interest points below.

1. Goring

The Catherine Wheel is the oldest pub in Goring, built in 1669, although it did not become a pub until 1892, when it came under ownership of the Goring Brewery. Just round the corner is the Temperance Hall (1878), conveniently placed to 'counteract the effects of too much alcohol' as the Catherine Wheel was only one of five pubs in the village! A stroll around Goring itself is a delight when armed with some information on the many buildings within a very short circuit: the village smithy, Ferry House (the home of 'Bomber Harris'), the John Barleycorn, the old Vicarage, Lybbe's Almshouses, the Norman church, the mill and bridge – all offer an interesting insight into this pretty riverside town. (For further information see the BEHG website).

2. Hartslock Nature Reserve

The reserve contains a good area of chalk grassland and it is of national importance for the conservation of typical and also rare species of this environment. Like all chalk grassland, the soil at Hartslock is very nutrient poor. In much of the reserve there is only a very thin covering of soil, sometimes leaving bare chalk at the surface. However, despite the poor soil, this reserve is home to over 2,000 species of plant, animal and fungus! Depending on the time of year, it is possible to see a wealth of chalk grassland species, including chalk milkwort, monkey and lady orchids (and a rare hybrid of the two), Adonis blues, along with a variety of other butterflies, a daytime moth (called a pyralid moth) and rare solitary bees. Also, the rare Pasque flower has been reintroduced to the site.

Above: Building materials in the church are local, sourced from the Chiltern Hills and from Headington in Oxford – beige Jurassic limestone (Oxford) and grey Totternhoe Stone with white Chalk Rock and black flints. (*Photographs by Jill Eyers*)

Right: St Thomas of Canterbury, Goring. This church was built between 1100 and 1125 by Lord Robert d'Oilly and originally dedicated to the Blessed Virgin Mary. It was re-dedicated to Thomas à Becket in 1180, ten years after his murder. (*Photographs by Jill Eyers*)

Below: View down into the valley cut by the River Thames and the Goring Gap. (*Photograph by Jill Eyers*)

Opposite: View from the Goring riverbank to Hartslock Nature Reserve. (*Photograph by Jill Eyers*)

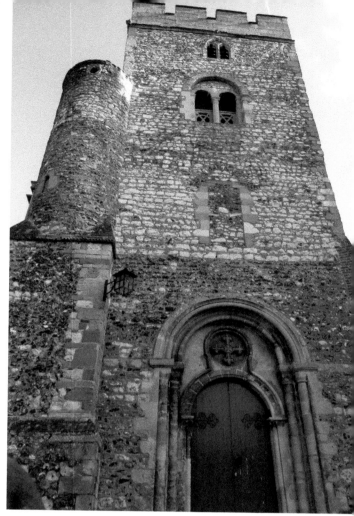

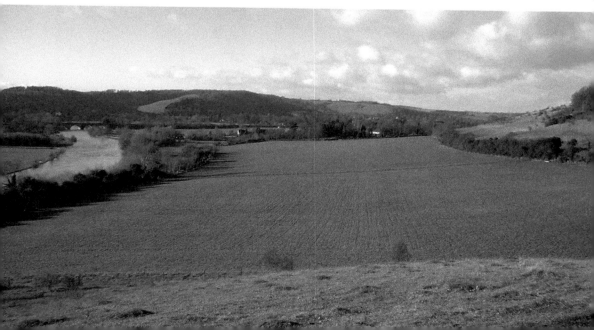

3. Goring Gap

The picturesque scenery below the reserve is actually a very new landscape (geologically speaking). It is only about half a million years old. Before this time, the hills and the Thames were not in this location. The landscape would have been very flat, perhaps rather like East Anglia today. The sudden and dramatic change to the landscape occurred during the Ice Age. At this time, the proto-Thames had a source in the Birmingham area and flowed south towards Oxfordshire, but then veered north-east across Norfolk and into the North Sea near Ipswich. The Thames did not come through Oxfordshire, Buckinghamshire and on towards London like today. However, half a million years ago, an ice sheet (known as the Anglian ice) pushed down from Scandinavia across England and past the Chilterns. The whole country became a frozen waste. At the end of this glaciation there was a sudden rush of meltwater, which resulted in river flow becoming torrential. North of Goring, the path of the proto-Thames had its old valley blocked by the retreating sheet of ice. The result was the cutting down of a new course for the river southwards. The waters cut deep incisions into the chalk rock and made a series of 'gaps' or valleys. Goring Gap is a good example of one of these features, and one that changed British history forever. The Thames would now flow on to reach what would later become London.

4. Railway Bridge

Looking down from the Hartslock reserve, the elegant brick railway bridge across the river can be seen. This was built during the 1830s by Isambard Kingdom Brunel, one of the country's greatest engineers.

5. Little Meadow

This pretty, natural hay meadow alongside the Thames is managed for wild flowers by the Goring and Streatley Environment Group. This is a good summertime place for nature spotting.

Goring bridge and mill. (*Photograph by Jill Eyers*)

6. River Thames

The Thames is a meandering river today, like all English rivers. However, this has only been true for about 10,000 years. Rivers that were in existence before this time – during the Ice Age – were all braided rivers. Braided rivers flow torrentially at times and then dry to a trickle, flowing in sinuous braids of narrow water channels. They rely on run-off such as melting snow and ice. Meandering rivers, like the Thames, are more consistent in their flow – relying mostly on the through-flow of water coming from the water table and through the rocks. Today, we control the amount of water in the river in an attempt to even out the flow, increasing the water level in summer and reducing flow when the need occurs during a wet winter. The lock by Goring Bridge was first constructed in 1788 and is now one of a few that have a third pair of gates inside the lock enclosure. These gates are to make the lock smaller and so save water, but they are not often used.

7. Ancient routeways

Goring is the ancient meeting place of three intersecting transport routes: the River Thames, the Icknield Way and the Ridgeway. The Ridgeway is an ancient pathway used from Neolithic times around 6,500 years ago. It is 85 miles long, connecting Avebury (Wiltshire) with Ivinghoe Beacon (Bucks). The Icknield Way is also thought to be an ancient trackway. It is thought the name is derived from the Iceni, the British tribe in Norfolk that later became famous for their female queen, Boudicca. The tribes probably traded along these routes. The name 'Thames', like all our river names, is Celtic and it was the only good transportation route for ancient people until the Roman period. The more recent Thames Path follows the river for 184 miles (see the information board by the Goring Bridge).

On the other side of the bridge is Streatley, which used to be an important stop on the turnpike road to Reading. There was no bridge connecting the two towns until 1837, although from Roman times the river could be forded – large stones, put in place by the Romans, still mark the fording place in the riverbed. Streatley, as a turnpike stop, was therefore much more important than Goring until the bridge was built. Before this time, the river completely separated the villages and a ferry was the only way across. However, this was not always a safe crossing. In 1674, sixty people drowned when the boat capsized over the weir. Once the bridge was in place, Goring then grew very quickly during Edwardian times and many of the buildings in town date to this period. Streatley fell out of favour and has probably led to the continued rivalry of the two places today!

8. Goring Water Mill

A mill was first present on this site before the corn mill recorded in the 1086 Domesday Book. In 1895, the mill was converted to generate electricity. The present mill building dates from the 1920s when it replaced the older building – it is, in fact, a replica of that mill.

OS Explorer Map 171 *Chiltern Hills West*.
Geological sheets 268 (*Reading*) and 254 (*Henley*) 1:50,000 series.
Grid refs: Goring SU 060 805 Goring village centre.

2

Swyncombe Downs

A Journey to the Pig Valley!

[From the Old English *swyne* (pigs) and *cumb* (a steep, bowl-shaped valley).]

The tiny hamlet of Swyncombe lies about 3 miles south of Watlington, next to Britwell Salome. The parish of Swyncombe, like many in this area, was already well established by Norman times and appears in the Domesday Book 1086. The church is early Norman with some remaining Saxon structure. The ancient ridgeway passing through this area would have provided good communication with surrounding farms and villages, such as nearby Watlington and the River Thames. Indeed, there is a long history recorded here, with finds and significant landscape features showing people have lived and passed through here from the Palaeolithic time onwards.

One of the ancient landscape features is a long, straight ditch that forks at one end. This is on the Downs and even today is a notable size. It is easy to see how these features would have formed important land boundaries. But who built them – the local tribe, a family or extended family group – and why? It is thought to be possibly Iron Age, so around 2,800 years old, and there are several ideas on the purpose of the features. However, it is thought most likely that they formed a land division and may have been partly ownership markers, but also part animal husbandry, by keeping animals contained one side and thus preventing them access to arable fields. Today, there is a line of more than forty mature beech trees along its length and some have girths of more than 4 metres. The form of the trees reveals clues to past management, as pollarding or coppicing are used in different circumstances. A pollard is where the branches have been cut and harvested higher up the trunk, leaving the new, luscious growth out of the reach of browsing animals such as cattle or deer. A coppice forms where the tree is cut low down in the trunk and would be a harvesting style where grazing by deer or cattle was not a problem.

OS Explorer Map 171 *Chiltern Hills West.*
Geological sheet 254 (*Henley*) 1:50,000 series.
Grid ref: SU 680 914 centre point Swyncombe Downs.

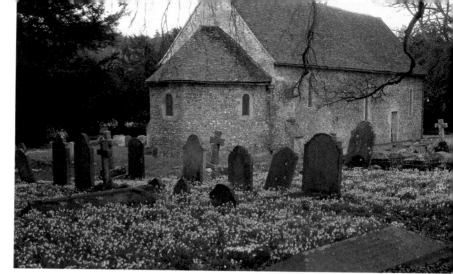

Swyncombe church – St Botolph's is a very early Norman church and it has a reputation for a good show of snowdrops in early spring. (*Photograph by John Morris*)

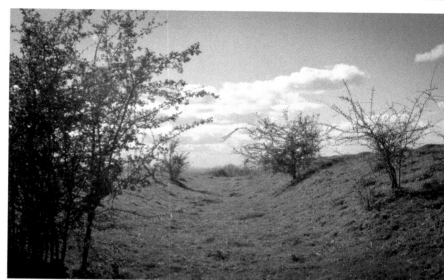

The Swyncombe earthworks – clear remains of the ancient ditch and bank that have divided this landscape since at least the Iron Age 2,800 years ago. (*Photograph by Hayley Watkins*)

Coppiced trees on the bank, evidence of long-term wood management on these ancient trees. (*Photograph by Hayley Watkins*)

3

Watlington Village and Hill

A Journey to the People of Wæcal's Village

[From the Old English personal name Wæcal, *ingas* (people of) and *tūn* (village).]

The Anglo-Saxon name indicates a particular group of people were living in Watlington at that time led by Wæcal. A ninth-century charter mentions it as having eight 'manses', or substantial buildings. At the time of the Domesday book 1086 it is recorded as an agricultural community valued at £610, and by the 1300s the street plan of today's older centre would be recognisable, while many of the buildings were erected during the fifteenth and sixteenth century. By the eighteenth century, the town had grown and was an important coaching centre with six inns.

Watlington is a typical Chiltern's strip parish. These parishes are long and thin and are orientated so they incorporated a good mix of landscape and resources required for the inhabitants. This ensured the parish had good arable soils on the low ground, water sources (via wells or at springs at the base of the scarp), sheep grazing land up the scarp slope, and common fields, woodland and isolated farms from the scarp slope to plateau area. Outside the village, the hamlets and farms were situated within the scarp coombs, such as Watcombe and Swyncombe.

The view towards the hills shows the famous Watlington White Mark. This is a very unusual folly cut by a local squire (Edward Horne) who felt that the parish church of St Leonard, when viewed from his home, would be more impressive if it appeared to have a spire. To allow this visual effect, he had the 82-metre-long cut made in Watlington Hill in 1764.

OS Explorer Map 171 *Chiltern Hills West*.
Geological sheet 254 *Henley* 1:50,000.
Grid ref. SU 691 945 Car park central Watlington.

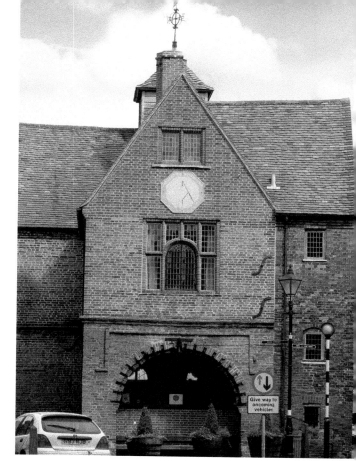

Watlington old town hall, built in 1664/65 by Thomas Stonor, Lord of the Manor. (*Photograph by Hayley Watkins*)

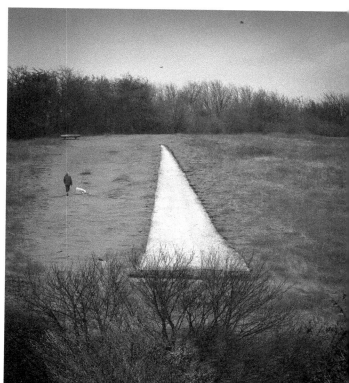

Watlington White Mark. (*Photograph by Hayley Watkins*)

4

Christmas Common to Cowleaze Wood

A Journey Through Trees and Bluebells

[Cowleaze is possibly derived from 'cow' and a corruption of '*leah*', meaning the clearing for cattle. It is interesting that ancient earthworks to the north-east of this site were destroyed as the motorway was built and these were believed to be an animal enclosure. There are also similar earthworks to the south-west, but these have never been investigated. Nearby, the name 'Christmas Common' has uncertain origins and the two proposed interpretations of it are: (1) that is named after a 1643 Christmas Day truce between combatants in the Civil War; (2) that it is named after a local family with the surname 'Christmas'.]

However it was named, this hamlet and common has only ever had a small, recent population – for instance, the 1811 census records only six houses. However, there is a much more intriguing past history. In the Iron Age, this was an area with a village of roundhouses, surrounded by wicker fences for safe enclosure, with fields and animals grazing nearby, and of course, woodland management just as today. The area lies close to the Ridgeway, an important ancient route and the hilltop is full of little holloways marking ancient footpaths where feet passing for many generations have worn out a hollow track.

The woodland (on the Stokenchurch side of Christmas Common village) has a large car park from which to explore the woodland of Cowleaze Wood. Exploring the woodland on the many diverging footpaths will reveal a variety of flora and fauna, depending on the time of year. In the spring, the bluebells are a spectacular profusion of shimmering blue, and in the summer the darker floor is lit intermittently by shafts of light where woodland flowers bloom.

Like many of the Chiltern hilltops, there is a round depression to be discovered in the central woodland. This is a sink hole (also sometimes called solution hole, swallow hole or swilley). It is a location where the chalk hills are literally being dissolved away. They occur at intersections where joints (regular fractures in the rock) cross each other. Rainwater passes through the joints much faster than through the pores in the chalk, and it is quickest at the intersections. The faster dissolution results in round or oval holes, which can be anything from a couple of metres to 100 metres. Certain horizons in the chalk can cause problems when the solution hole may suddenly give way. The holes cause danger if they undermine houses or roads. This problematic sink hole has chalk overlain by sands or clay. Here in the woods the chalk is at the surface and so this sink hole has formed very gradually over thousands of years and is not prone to sudden collapse.

OS Explorer Map 171 *Chiltern Hills West.*
Geological sheet 254 *Henley* 1:50,000.
Grid ref. SU 727 957 car park Cowleaze Wood.

Above: Bluebells in Cowleaze Wood. This pretty carpet of blue may be seen in spring shortly before the tree canopy develops and darkens the floor for the summer months. Scenes such as this have inspired artists for many generations. (*Photograph by John Morris*)

Right: The ancient earthworks at Greenfield Copse, which have not yet been investigated by archaeologists. Who built them and why? Are they part of an Iron Age enclosure for habitation or a later animal enclosure? The lack of knowledge and continuing investigation of our Chiltern landscape is what makes archaeology so exciting. (*Photograph by John Morris*)

Below right: A sink hole in the woods. These depressions are common features on chalk, although very few people realise what they represent. They are places where the 'solid' rock is being dissolved away and collapsing, leaving hollows. They should not be confused with quarry pits (which, although they look like similar depressions, will nearly always have a track entrance for barrows or carts to remove the quarried materials). Sink holes have no break in the edge for an entrance or exit point. (*Photograph by Hayley Watkins*)

5

Aston Rowant Nature Reserve

A Journey to Rowald's Eastern Estate

[From: Old English *ēast* (east), *tūn* (village or estate) and personal name Rowald. Rowald de Eston owned the land in the thirteenth century.]

This nature reserve offers wonderful views of the Vale of Oxford from the chalk escarpment, and on a clear day you can see all the way to the Cotswolds. An interesting walk commences from the car park where a circular trail can be followed that will go past a platform viewpoint, down steps to an ancient holloway, turning right when emerging at Beacon Hill and another viewpoint, then over downland to turn right into Little London Wood. Once through the wood, a final turn right on the roadway leads back to the car park. The walk incorporates an insight into the underlying rocks, some archaeology and a variety of habitats, such as beech woodland, scrub and chalk grassland. There is a very high likelihood of seeing red kites.

There are several sandy types of sarsen scattered on the edge of the roadway and within the car park of the nature reserve. Although the stone has been moved to this location, they have not come far, being sourced from the nearby M40 motorway cutting.

The stone is often encountered at depth and an elderly resident of Stokenchurch recounted how he used to walk the local fields with his father and a team of men searching for sarsens. This was a common sight from the Victorian period through to the 1940s. One man would have a long pole he would probe into the ground. If it hit anything hard, the call would go out and a team of diggers would come in to locate the stone. The sarsen was then cut by another team. It was apparently only workable for twenty-four hours after uncovering. After this time the sarsen would harden so much that it could no longer be cut into the setts required for building and paving purposes. Sarsen is a form of sandstone that has quartz cement and is exceptionally hard-wearing. It formed 50 million years ago (as part of the Reading Formation) within a semi-arid desert. On the rare occasions when intermittent rain fell, the water would run as rivers depositing sand, as here, or sand and pebbles as with Bradenham (*Trail 18*) or Cholesbury (*Trail 22*). Quartz cement only forms on land, where wind-blown dust becomes moistened by dew at night on or just below the surface. On re-drying it forms crystals tightly holding the sand grains together. Many millions of years later (during the Ice Age), the sarsen stone was shattered by freeze-thaw. The broken blocks were gradually moved by gravity on newly cut slopes and water washed the smaller pieces away.

At the look-out platform, just a short distance from the car park, note the very large sink hole to the right by the gate. This is one of several along this height on the escarpment, another one in Cowleaze Wood was mentioned in Trail 4. The view from this point displays how the harder chalk forms the escarpment, tilting slightly to the south-east, and dropping suddenly at

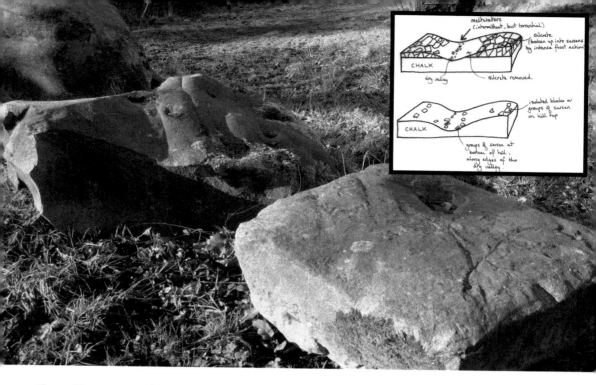

Inside the inset sketch:

meltwaters
(intermittent, but torrential)

silcrete
(broken up into sarsens
by intense frost action)

CHALK

dry valley — silcrete removed

isolated blocks or
groups of sarsen
on hill top

CHALK

groups of sarsen at
bottom of hill,
along edges of the
dry valley

Above: The sarsens at the entrance to the nature reserve are a sandy type often called Denner Hill stone due to the large amount quarried from that locality (near Lacey Green) during the Victorian period. These specimens show the typical grey colour, ripples and branch holes, and on closer view it has a 'sugary' appearance due to sand grains being cemented with quartz. (*Photograph by Jill Eyers*)

Inset: Sketch of how the solid beds of sandstone became broken up to form loose blocks that we now call 'sarsen stone'. (*Sketch by Jill Eyers*)

the scarp edge. The low ground stretching out into the very far horizon is composed of softer sediment (clays and sands). On a day with good visibility, the next hard rock encountered is the limestone of the Cotswold Hills, again the hard rock forming the higher topography.

Walking through the gate, down the steps and turning right at the bottom path, the sunken way is discovered. This is a holloway and has literally been worn down over thousands of years by many feet (probably both animals and humans). People would have first settled in this landscape during the Neolithic period from 6,500 years ago when we became farmers. These settlements would have been located at the bottom of the scarp, as this is where springs bring fresh water to the surface. However, the essential commodity of wood (for fuel and building) would soon have been used up from around the settlement. The Chiltern hilltops would become the source of wood, but also animals would be moved to hilltop grazing at certain times of the year. The traditional pathways up to these locations soon wear into these well-formed holloways.

On emerging out of the holloway walk, continue walking clockwise around Beacon Hill past abundant 'bumps' in the chalk grassland (built by a specialist inhabitant known as the Yellow Meadow ant).

The route then goes past the yew trees and scrub, and onwards to Little London Wood – watching out for wild strawberries and other woodland edge plants. The footpath follows a hollow area to the right. Note, this is a small pit dug into the Clay-with-flints deposit. It is not a sink hole,

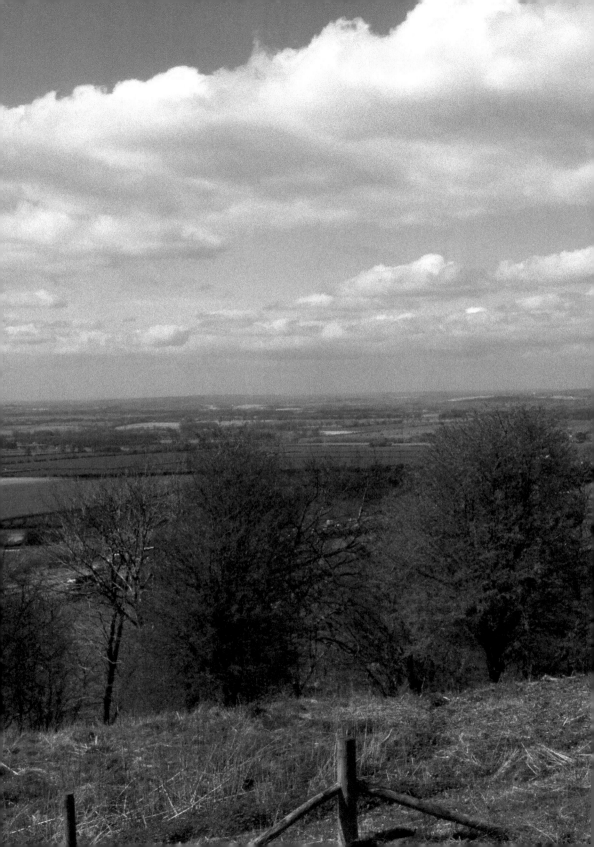

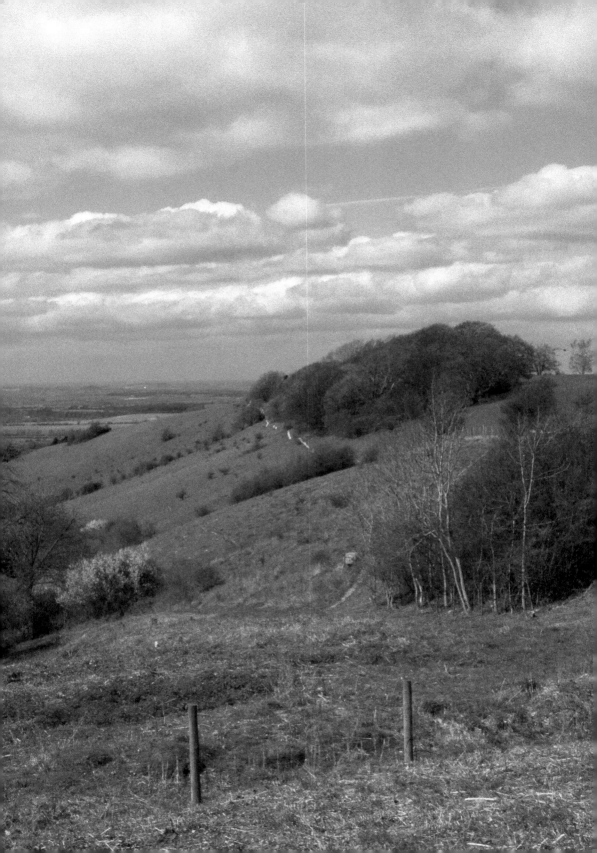

as there is a clear track into it for transporting the extracted flints from this pit. As you continue to pass the beech trees in the wood, note there are clusters of beech that are similar sizes (indicating similar ages). This is a survival strategy of the tree and the age separation of the clusters is seven years. The trees are the result of 'mast years'. Mast is the name given to the beech fruit, which has a hard outer casing, and which are tasty food for many woodland animals. However, as no browser or pest species has a life cycle that would fit into seven years, this means that if a species benefits from a glut in a mast year, the increase in their population will not be rewarded by a similar glut for the next generation. The browser population will be kept under control this way, and beech fruit survives to germinate and grow – a clever strategy.

OS Explorer Map 171 *Chiltern Hills West*.
Geological sheet 254 *Henley* 1:50,000.
Grid ref. SU 732 967 car park Aston Rowant Nature Reserve

Above: The sunken way – an ancient holloway at Aston Rowant Nature Reserve. (*Photograph by Hayley Watkins*)

Previous page: View across the Oxford Vale from the scarp edge. The chalk ends abruptly at the 'tilted' edge and all the soft clays and sands that lie beneath the chalk stretch out in the low vale beneath. The geology thus gets older and older into the distance, until the Cotswolds (Jurassic in age) are reached in the very far distance. (*Photograph by Hayley Watkins*)

6

Chinnor Hill to Bledlow and the Cop

A Journey from Ceonna's Hill to Blaedda's Burial Mound

[Chinnor: from *ceonna* (an Anglo-Saxon name) and *ōra* (flat-topped hill); Bledlow: from Blaedda (a personal name) and *hlāw* (a burial mound); Cop: Anglo-Saxon *copp* for summit.]

This 5.5-mile (9 km) circular walk (or a shorter version of 2 miles [3 km]) explores the beautiful Chiltern landscape from the suggested start in Chinnor at the foot of the chalk scarp, up the hill to the dip slope on the wooded top and over to 'the cop'. From this high point you can appreciate how geology makes scenery, but also how people have used and shaped that landscape since our earliest times. These uses include obtaining local flint for stone tools and knapping for buildings, quarrying chalk for cement manufacture, using the spring lines for water, and understanding the suitability of different soils for crops.

The best start is from the Chinnor village hall area. If embarking on the longer walk, there are several pubs in Chinnor for refreshment and The Lions pub provides good food in Bledlow.

The route: From the village hall follow the road past the shops, turn right and follow the road to a track leading over the railway. Shortly after the railway line turn left (1) and follow the paths along the scarp (2) towards Bledlow (3). (Shortcut: When you get to a tarmac road near Hempton Wainhill you can turn right and then right again onto the Ridgeway. After passing a house on your left turn right on the footpath and walk back into Chinnor for a shorter route.) On the longer walk, you will reach The Lions in Bledlow (4) and then turn due south heading uphill to the Ridgeway. Where the track meets another at the T-junction you need to turn right, but before you do so, you might like a little excursion – a few hundred meters up the hill to the Cop (5). You reach the Cop through the gate opposite and take the right track directly uphill. Keep looking to your right and eventually you will see a mound (*tumulus*) known as the Cop. From here, return to the path continuing west towards Hempton Wainhill. Take a left path following the signs to 'Chinnor Hill and the Barrows'. It would be easy to miss the burial mounds known as the Barrows (6), but the sign on the fence tells you when you should look out for them. Go through the gate to investigate them further and also to look at the view (7). Now continue south, back on your path, where you encounter the main area of Chinnor Hill (8). At the tarmac road, turn right onto a footpath about 50 metres past a post box. The path descends steeply down the escarpment. On reaching the Ridgeway path you can turn left onto the Ridgeway (9), across a road and take a quick look at the views into the old chalk quarry (10). Chinnor can now be reached more quickly via the road you have just crossed. Turn left onto this road returning to Chinnor past the railway station.

The trail interest points:

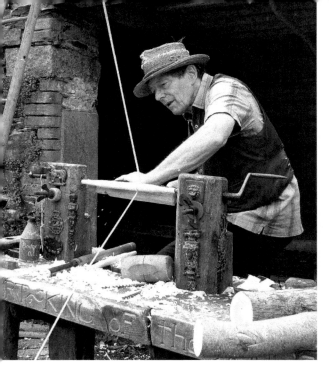

Above: Ancient and modern: Chair bodger Bobby Wingrove working in Winchmore Hill (*right*), and modern-day 'bodger' Stuart King. (*Photographs by Stuart King*)

Below: The quarry face at the old Chinnor cement works as it looked in the mid-1990s – a scar in the hillside created by extraction of soft, clay-rich chalk for the cement-making process. (*Photograph by Jill Eyers*)

View of the fields across the vale from the scarp edge. (*Photograph by Hayley Watkins*)

1. As you leave Chinnor think about what information lies in the name. Chinnor is derived from '*Ceonna*' and '*ōra*'. The former is an Anglo-Saxon man's name and an '*ōra*' is a flat topped hill. So the town was named after a person and the shape of the hill it lies beneath. Clearly Anglo-Saxons lived somewhere nearby, and maybe directly within, the modern town. Farming would have always been a mainstay of the community, but it is noted in the 1851 census there was a substantial cottage industry in lace, with 256 lace makers in the town. Lace makers started to learn their craft as young as five years of age – these early apprenticeships being in the school. Woodland management was also very important as the same census records forty-three leg turners (known as bodgers) working in the woods.

Bodger was the name given to the many pole lathe turners working in the furniture industry in the Chilterns. They often worked in the woods where they had bought their timber lots from woodland owners, turning items in their shelters made of wood with a thatch cover (later corrugated iron roofing was used). Every leg, spindle and stretcher destined for furniture – such as the famous chair industry of High Wycombe – were turned by these men working in the woods or in sheds in their back gardens. Technology and changes in furniture fashion resulted in the last of the professional bodgers being seen in the woods by the 1950s.

The year 1908 saw a dramatic change for Chinnor as Mr Benton's Cement & Lime Works opened. Production increased until its peak in the 1990s of 5,600 tonnes per week and the employment of 120 people. Cement works are always located at the foot of a chalk scarp as they need the soft, clay-rich lower chalk, mixed with a little hard middle chalk with a few other ingredients.

2. Chalk scarp

Chinnor lies within the flat expanse of land stretching out from beneath the chalk hills. The scarp shows the boundary of where harder chalk begins and soft clays and sands lie within the vale. The scarp is the point of erosion today, where the chalk has been removed from the vale to this point over many millions of years. However, there would not be a scarp slope at all if the chalk were not tilted. This tilting occurred during the Alpine mountain building (50 to 10 million years ago). This event produced the Alps and the Taurus mountains in Europe – and tipped up the English chalk by a few degrees! A seemingly small amount, but crucial for the Chiltern landscape.

The farming landscape is laid out in the vale below as a patchwork of fields, the boundaries marked by fences and hedges. These boundaries have only been formalised by fencing since the Enclosure Acts, most of which were in the 1860s. However, they are often reasonably precisely aligned with more ancient ones. It is a commonly held view by archaeologists that the co-axial field system seen in and around the Chilterns marks the Bronze Age field systems of more than 3,000 years ago, and potentially much older than that.

It is also known that the Romans were farming here, one of their farmhouses (a villa) lies beneath Lower Wainhill. But the Romans inherited an already farmed landscape – the larger field boundaries mark the same fields farmed by Iron Age and Bronze Age people.

3. Bledlow is named after the burial mound (locally known as the 'Cop') on the hill overlooking the village. The name Bledlow is derived from the Anglo-Saxon Blaedda, which is a person's name, and *hlaw*, which is a burial mound. This person must have been very important to have had such an important monument for burial.

4. The Lions at Bledlow

This seventeenth-century pub is a good place for lunch and a must for *Midsomer Murder* fans where you will recognise The Lions as the 'Queens Arms' and the 'Badgers Drift church' is just up the road. The pub was originally two adjoining pubs: the Red Lion and the Blue Lion. When they merged the name changed to 'The Lions', but you can still see the two front doors.

5. The Cop

Finally, you will reach the burial mound on the hill overlooking Bledlow, although it is mostly hidden within the trees today. However, when this burial was put in place, the hillside may well have been bare of trees, wood being in great demand for huts, equipment and firewood. A great many of these burial mounds (often marked *tumuli* on maps) are early Bronze Age in date. But mounds that look very similar may be Anglo-Saxon or, less often, Romano-British in age. This example is thought to be Bronze Age – a primary burial occurring 4,600 and 3,600 years ago was excavated in 1939. However, this date has been disputed as perhaps being Saxon as a leg bone and artefacts were also found belonging to this era, but this had been disturbed in the seventeenth century when items were removed. It certainly seems as though the Saxons (from AD 410) knew the name of the deceased (Blaedda), so some credence must be given to this idea, and it is well known that secondary Saxon burials sometimes occurred into the sides of Bronze Age mounds. The mound would have originally been higher and it may have had a surrounding ditch that has since silted up. It is very common for these barrow burials to be placed high in the landscape and on the sides of hills with a good view (presumably for the people below to see it, rather than for the deceased to enjoy).

6. The Barrows

A further two barrows can be found on Chinnor Hill. These are large (23 metres and 24 metres in diameter, and just over 1 metre in height) with a surrounding ditch forming a figure of eight pattern, which can just be seen with a careful look. The ditches are about 1.5 metres wide, but now only about 30 cm deep due to silting up over time. They certainly have had a good deal of time to do this – they are Bronze Age burial mounds dating to between 4,600 and 3,600 years ago. However, an Anglo-Saxon inhumation burial is known to have been dug into the side of one of the mounds.

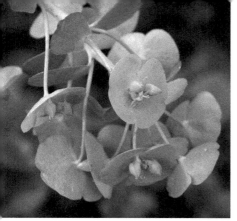
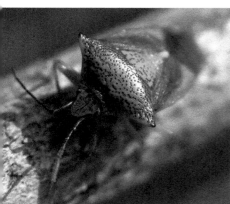

Above: A pyramidal orchid (*right*) from the open grassland, wood spurge (*above left*) from the shady woodland) and a juniper shield bug from the juniper scrub (*below left*). Juniper was once common, but it is now quite rare in its natural habitat. Losing juniper scrub means losing all the species relying on it, notably the specialists such as this bug. (*Photographs by Hayley Watkins [flowers] and Jill Eyers [bug]*)

Below: The Ridgeway at Chinnor. (*Photograph by Jill Eyers*)

7. The View Across the Vale
Looking out from the top of the chalk hill, the whole of Chinnor and a patchwork of fields are laid out beneath. The chalk is a relatively harder rock than the soft clays forming the vale beneath. As a result, it stands up proudly as the Chiltern Hills. On a clear day, some small 'bumps' can be seen along the far horizon. These small hills are the Jurassic rock of the Midvale Ridge underlying villages such as Long Crendon, Chearsley, Upper Winchendon and Brill. Again, being limestone they are harder and therefore form high points in the landscape.

8. Chinnor Hill Nature Reserve
This walk on Chinnor Hill around 2,500 years ago would have passed by the Iron Age village, which was near the car park and next to the modern housing. By exploring, it is possible to find two sunken ways, which are two ancient tracks, perhaps linking the Iron Age settlement to their woods and fields. The hollows of these tracks were worn over time by the action of lots of feet!

Chinnor Hill is a rich environment for wildlife. It varies from the chalk grassland leading up the scarp slope from the Ridgeway to juniper scrub, finally culminating in the beech woodland at the top of the hill. The grassland is filled with a profusion of wild flowers at various times of the year – primroses, cowslips, spotted and pyramidal orchids, twayblades, rock roses and agrimony. The juniper scrub is not just flavouring for gin, but is home to a diverse insect fauna, some are quite rare, such as the juniper shield bug.

In contrast, the violets, white helleborines and wood spurge of the shady woodland floor are very pretty in the summer. These plants thrive in the shady conditions on the dry, poor soil. The beech woodland is growing on the Clay-with-flints deposit capping the hill. There are a large number of irregular pits and depressions in the ground at this point, which are old workings for flints. Most of these flints were for buildings – churches, walls and for the traditional Chilterns' house style of little brick and flint cottages.

9. The Ridgeway
This ancient pathway – all 87 miles (139 km) of it – has been in use since the Neolithic period, perhaps from as long as 6,000 years ago. It would have started as a wide open trackway; the hedges only confined it after the enclosure of the mid-1800s. For thousands of years, this has been a major arterial route for transporting people, animals and goods, a little like the M25 of today.

10. Chinnor Cement Quarry
Chalk has been extracted for cement-making from this quarry since 1908. At the height of production, the quarry manufactured 5,600 tonnes per week. The quarry finally closed in 1999 – it was saved from an earlier closure by a sudden need for more cement for a large project called the Channel Tunnel! In fact, the channel boring machine had a test-run in this quarry before tackling the tunnel. Cement requires a vast amount of Lower Chalk, which, unlike the Middle and Upper Chalk, is not hard, but is very soft, chalky clay. The 'holes in the ground' that the extraction has produced, fill up with rainwater and turns to a beautiful blue colour due to fine particles in suspension.

Map: OS Explorer 181 *Chiltern Hills North* 1:25,000.
Geological map: British Geological Survey. Sheet 237 *Thame*.
Grid refs: Chinnor SP 755 008 (central); Bledlow SP 779 023.

<div style="text-align: right">7</div>

Monks Risborough and Whiteleaf

A Journey through the Monk's Brushwood Hill to the White Cliff

[From: Old Norse *hris* or *hrĭsen* (meaning brushwood) and *berg* (meaning hill), and the prefix was added later on by the Middle English *Monke*, to signify the monks' ownership. Whiteleaf is a misspelling of Old English *hwĭt* (white) and *clif* (cliff).]

It would be easy to drive through Monks Risborough without noticing you have left Princes Risborough and that you are now on the road towards Aylesbury. The A4010 takes you directly through it, without inviting you to stop, and in doing so you are bypassing a wonderfully historic area with some intriguing insights into human behaviour over time. To enjoy this area fully, first explore the historic church of St Dunstan's (by parking in Mill Lane and finding the footpath to the churchyard). After exploring the delightful church, walk or drive up the scarp and hill to the Whiteleaf Nature Reserve, where ancient history continues to unfold along with beautiful vistas over the Aylesbury Vale and villages below.

Monks Risborough is one of only a few places where you can find archaeological and literary evidence of people having passed through from the first hunter-gatherers to those who later settled in the area. The evidence includes finds and features for the whole period from the Ice Age (including the entire Stone Age) to the Bronze and Iron Ages, to Roman, Saxon, Norman and medieval times – continuing to the modern village inhabitants. Much of the archaeological information can be found by seeking out the local buildings and landscape from the church and surrounding roads and onwards up the hill to Whiteleaf and the nature reserve (which is well signposted).

The literary record for what we now call Monks Risborough starts with a rewritten Anglo-Saxon charter dated AD 903 (the original was destroyed in a fire). The Charter for 'East Risborough' describes the settlement as *margine luci Ciltern,* meaning 'by the edge of the Chiltern wood'. The document records the famous Black Hedge – the Anglo-Saxon marker of the parish land boundary, which people still respect today by taking part in the 'marking the bounds' ceremony on occasions. The Charter records that the land was owned by a lady called Æthelgyth. On her death, she must have bequeathed the land to the monks at Canterbury, as it is recorded that by the middle of the century they offered it as security on a loan from the bishop at Dorchester-on-Thames. The money was required as a payment to Viking raiders, in order to stop their attacks and to prevent the abbey at Canterbury from being burnt down! The monks finally paid off the loan to the Dorchester bishop and regained ownership of East Risborough some time between 994 and 1002. From this time onwards, the Canterbury rolls record the Monks administering control of the land for rents and agricultural income. From the mid-eleventh century (Norman), there was a major revival for the village – the population grew

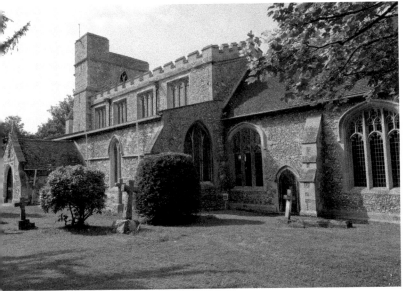

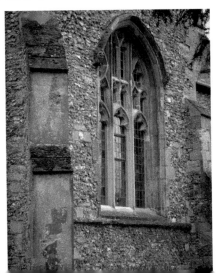

Top: The sixteenth-century dovecot in the park behind (north of) St Dunstan's church. The Saxon to medieval manor house was located where Place Farm was situated until last century, and subsequently where the modern housing in the distance has been built. (*Photograph by Hayley Watkins*)

Middle: St Dunstan's church, Monks Risborough. (*Photograph by Hayley Watkins*)

Bottom far left: The 2013 excavation of the new graveyard extension at the point of discovering the builders' rubble from demolition material from Roman villa and repair to church during the mid-eleventh century. (*Photograph by Jill Eyers*)

Bottom right: The north wall of St Dunstan's church, Monks Risborough, showing a vast selection of building stone, much of it is recycled Roman material. (*Photograph by Hayley Watkins*)

and boundary ditches were emplaced around a manor house (where the Place Farm housing estate is today). The court records from the fourteenth century include accounts of rebellions by the tenants, providing trouble for the bailiff (James Frysal). There were also threats to the monks from disgruntled tenants who were being charged too much rent. The accounts are quite clear that Monks Risborough was never a residence for the monks – they lived in Canterbury and administered their land from there. Similar to many monasteries, the monks were rich landowners renting to tenants.

The church of St Dunstan's must have been part of the initial revival and rebuild in the mid-eleventh century. It is known that the Normans put a lot of money into churches and monasteries, and deep, important ditches were dug around the church area at this time. The church is named after Dunstan, a very popular tenth-century Canterbury monk who was canonised in AD 1029. The church was originally thought to be fourteenth-century, but after excavations for a churchyard extension in 2013, a Norman date was proved by finding mid-eleventh century builders' rubble from a church repair.

Looking beyond the village itself there are at least two holloways that lead up the hill to the top of the scarp. One way passes the hamlet of Whiteleaf and one goes directly up to the Whiteleaf Nature Reserve.

Walking around the nature reserve it is fairly easy to find more evidence that this was a much-used landscape. People made divisions in their landscape from the earliest of times. The long mound near the scarp edge is a Neolithic burial mound and it is one of the oldest monuments in Bucks, being 5,700 years old. During excavations, it was found to contain a male skeleton – the body of one of the local inhabitants. The skeleton showed signs of arthritis and tooth abscesses, and he was around forty-five years old, which was the norm for 'old age' in the Neolithic.

People were not buried in the Neolithic, but were excarnated (a process whereby the body is laid out on platforms for birds of prey to consume the flesh). The cleaned bones were then collected and placed in mortuary chambers. Here, at Whiteleaf, it was a wooden structure, which made use of a split tree trunk (trees were very special and very revered items). The mound of earth and broken chalk was later placed over the wooden mortuary chamber and was maintained with fresh white chalky earth until between 50 and 150 years after the man's death. This is thought to be signs of continued respect and perhaps associated with feasting around the grave – as substantial amounts of pottery sherds and bone were also found. There are also later (Bronze Age) secondary burials such as a child's cremation and others buried into the side of the original mound. Numerous ancient banks and ditches (the cross-ridge dykes), as well as the field system lying across the vale beneath the hill, all testify to Bronze Age people living, dying and farming the area.

The Whiteleaf Cross is close to the burial mound and it is a very distinct feature cut into the chalk. However, there is some controversy about its age. The first mention of it is not until a description by Francis Wise in 1742, and so it may not be as old as other chalk figures around the country.

OS map Explorer Sheet 181 Chiltern Hills North.
Grid refs: Monks Risborough SP 812 044 (church); Whiteleaf Nature Reserve SP 823 036 (car park).

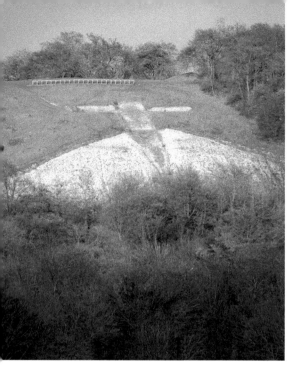

Above left: The Whiteleaf Cross, a notable emblem cut into the chalk, but it may not be older than eighteenth-century. (*Photograph by Hayley Watkins*)

Above right: The Aylesbury font in St Dunstan's church. (*Photograph by Jill Eyers*)

Below: The Neolithic burial mound on Whiteleaf Hill. (*Photograph by Hayley Watkins*)

Opposite: Pulpit Hill, as seen from Great Kimble. (*Photograph by Hayley Watkins*)

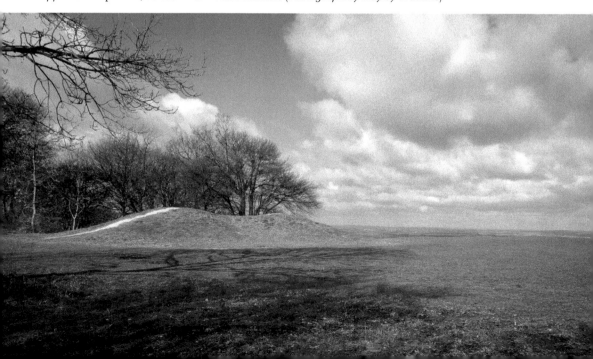

8

Pulpit Hill to Bacombe Hill

A Journey from the Scarp Edge 'Pulpit' to the Coomb at the Bend

[Bacombe from: the Old English *cumb* (a steep, bowl-shaped valley) and *bēgel* (Anglian) meaning a distinct bend. The area is located at a significant gap where there is a bend in the scarp. Pulpit Hill is undoubtedly a much younger name, probably Victorian, as is nearby Cymbeline's Mount. Victorians often named unusual features in the landscape with mystical or symbolic names. Both sites show ancient earthworks: Pulpit Hill is an Iron Age fort and Cymbeline's Mount is a motte-and-bailey castle (Norman). Nearby Ellesborough indicates that the Anglo-Saxons could see these features, as this literally means 'asses hill' from *esol* (Old English for an ass) and *berg* (Anglian for a hill, particularly an artificial hill such as a *tumulus* or earthwork).]

There are several ways to explore this area using the Ridgeway and associated minor footpaths, which can take you many ways to see Pulpit Hill, visiting Little Kimble on the way, with a view through Happy Valley to Coombe Hill and onwards to Bacombe Hill. For those who are not walkers, there are easy access points at each site with notably a stop at the church at Little Kimble and a view to Pulpit from Ellesborough from where a short stroll is possible to get the best views; or take a shorter walk from the Coombe Hill monument to Bacombe along the Ridgeway.

 Pulpit Hill is to be found east of, and midway between, Whiteleaf and Great Kimble and can be reached by parking in the National Trust car park nearby. The Ridgeway path passes right past the site, which is a close relationship seen at many other hill forts. It is a fairly small hill fort and is hidden within the woodland, but the earthworks are well formed and obvious. By tracing them round between the trees, the earthworks can be detected as a D-shape, with a double rampart at the east end (known as a bivallate fort). This hill fort, like many in the Chilterns, has never been excavated and so we know little about it. Archaeologists are beginning to question what these features were – clearly they are enclosures of some kind, but what

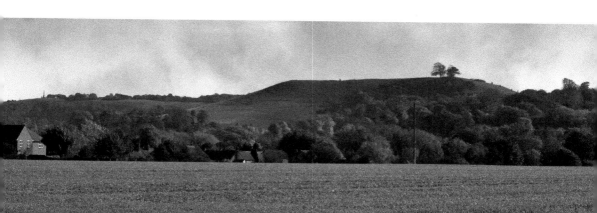

did they enclose? Many are not on hills and those that have been excavated often turn out not to have been forts – so the name 'hill fort' is becoming a little unfortunate! However, the location of this example, on a very steep-sided promontory with two V-shaped ditches and two associated banks, with a single entrance, might indicate a protective function. It also qualifies for the name 'hill fort' by being on a hill! Research is ongoing and will soon reveal more about these intriguing enclosures and who used them. For more on the occupants of the hill forts see the text on Boddington Camp under Trail 9: Wendover.

Little Kimble church is to be found on the junction of the A4010 with the Ellesborough B-road. This pretty little church is well worth a stop, not least because of the building stone itself – local sarsen and flint, with an impressive ammonite in the wall. It is fourteenth-century with a Norman font, medieval wall paintings and thirteenth-century floor tiles.

Coombe Hill is a very interesting area for wildlife. This is all due to the presence of a wide variety of geology underpinning the variety of soil types – from chalk grassland to acid, sandy heathland to clay woodland. Red kites are often seen soaring above the 260-metre hill, and on the ground a variety of plants can be found ranging from heather to orchids.

The monument at the top of the hill is a notable local landmark and is Grade II listed. It marks the loss of 148 local men in the second Boer War and was erected in 1904. It was almost destroyed by a lightning strike in 1938 and again hit by lightning in 1990. This is definitely not the place to hang around in a storm (although the monument now has lightening conductors fitted).

OS Explorers sheet 181 *Chiltern Hills North.*
Grid refs: Little Kimble SP 826 065 (church); Pulpit Hill SP 833 045 (car park) and Coombe Hill SP 849 067 (monument).

Pulpit Hill earthworks, part of the enclosure of the Iron Age hill fort. (*Photograph by John Morris*)

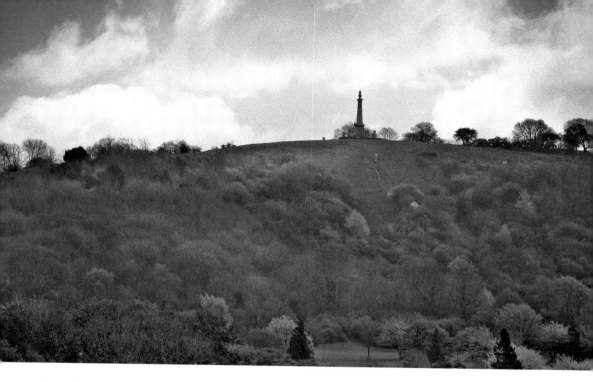

Above: The monument at Coombe Hill. (*Photograph by Hayley Watkins*)

Below: The fourteenth-century All Saints church at Little Kimble, with the medieval wall painting depicting St George (*inset*). (*Photograph by Hayley Watkins*)

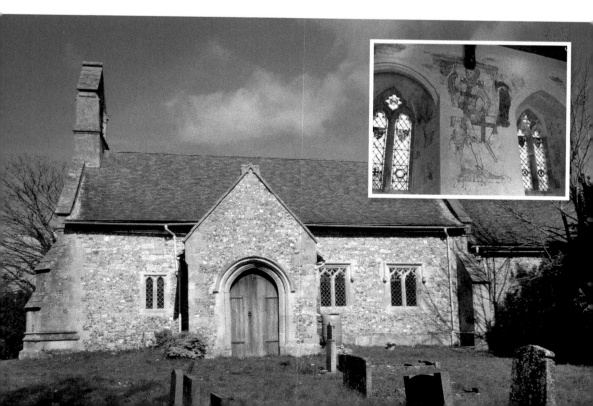

9

Wendover Woods to Wigginton

A Journey from the White River Spring to the Village of Wicga's People

[From: the Celtic name for 'white river *wen* emerging at the hill *over*' and the Old English personal name Wicga, *ingas* (his people) and *tūn* (village).]

Wendover is a typical Chiltern market town adorned with red-brick buildings, some with ancient timber frames, and you can just sense as you walk around the streets that they are steeped in history. It is an ancient borough on the Upper Icknield Way and lies within a gap in the Chilterns ridge. As the town lies at the foot of the scarp, where the springs are to be found, then its history of course started with hunter-gatherers, who would have made use of the fresh, pure water that later gave the Celtic name to the settlement. Where there is water, people will always settle – at least if the water source is surrounded by arable soils and has a plentiful supply of woodland nearby. Here, that woodland can still be seen all along the top of the scarp. A good place to explore it is in Wendover Woods to the east of the town and reached via the Halton road, by a turning on the right. The car park is located at SP 885 084 and is well signed as it is a well-known picnic site with many facilities and well-maintained footpaths to explore. These footpaths have different themes such as wildlife, jogging or the Gruffalo!

Hidden in part of the woods is Boddington Camp. This is a series of earthworks that once formed a large hill fort. What were the Iron Age people doing in the woods? This formed an enclosure, although it would not have been so heavily wooded at the time they were built. The line of hill forts in the Chilterns often spaces them out in such a way that it would provide a visual contact between them. Were they forts? It is now commonly believed by archaeologists that many, and perhaps the majority, were not 'forts' in the sense that they were defensive. Indeed, this is a good example of poor naming by archaeologists, as many of them are not even on hills! Some have been proved to have had a defensive potential, but the vast majority seem to have been enclosures as perhaps a meeting place. The sites were clearly important as they are often associated with the major trackways of the day. Here, Boddington is exceptionally close to the ancient Ridgeway path. It is therefore easy to envisage that they may have been so visually obvious because they functioned not just as meeting places but perhaps had religious functions, or were for celebrations or trading, and maybe all of these things. Some smaller 'hill forts' have been proved to have been animal enclosures, so it seems they had different functions and until they are investigated we will not know the answers. A current project, The Atlas of Hill Forts in Britain and Ireland, is investigating these enigmatic features of our landscape.

However, there are lots of things we do know about Iron Age people. This knowledge is based on finds from excavations of sites like this one, or from literary accounts by writers from the Iron Age to Roman period. The latter must be treated with caution for error or bias! From this

Boddington Camp is an Iron Age hill fort where the huge ramparts forming the enclosure can still be seen. This is the east side. (*Photograph by Hayley Watkins*).

evidence, it is clear that the *Catuvellauni* tribe that had control of most of Hertfordshire (with a capital in modern St Albans), then invaded the regions of Beds and Bucks and were very war-like. *Catu* means battle and the name means 'good in battle'. Interestingly, their most famous king, who died in AD 30, was Cunobelinus (or Cymbeline, and note this name does appear for a nearby hill mentioned in Trail 8).

We also know from written accounts that the Iron Age tribes in general were controlled and ruled by the Druids. The Druids were the source of all knowledge and they acted as decision-makers, advisors, doctors and gave out the law and punishment for each tribe. Their name shows an important Celtic element – *Dr* means 'tree' and in particular *Dru* is an oak tree, a highly revered living thing. As such, it was an apt name for this prestigious and influential group of religious leaders. We also know that the Iron Age people were highly superstitious. The druids would be consulted about upcoming events and asked for advice. Omens would be looked for and interpreted before any major decisions were taken, such as going into battle – or not. Bad omens were frogs, wrens, magpies and ravens. Good omens were fish (especially trout, salmon and eels), boars, cats, stags, bulls, the circle shape, goats (for fertility), geese (for war and protection), horses, snakes (for fertility and healing) and swans. Water was very special and wells would often have offerings made to them. Trees were very good spirits and little tiny rags were tied to the branches – you will still see this custom today in many parts of the world.

The reader may feel this was all a long time ago and not related to modern people exploring the Chilterns. How Iron Age are you? Test yourself with these questions and then look at the answer page at the end of the book.

Above: A bee on an orchid. (*Photographs by Hayley Watkins*)

Left: If you go down to the woods today ... you will find a bear in Wendover Woods. (*Photograph by Hayley Watkins*)

Below: Wigginton Woods. (*Photograph by John Morris*)

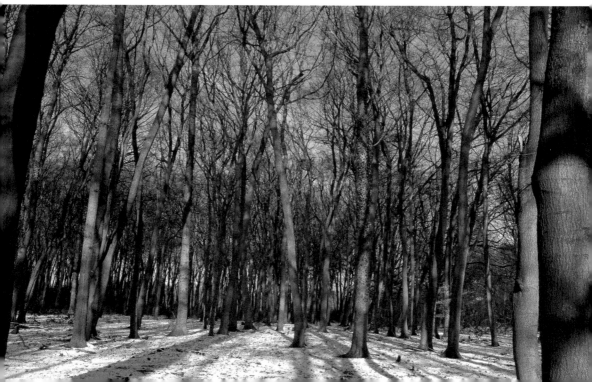

1. Do you have a lucky number?
2. Have you ever thrown a coin into a fountain, well or pool?
3. Have you danced, or watched, a maypole dance?
4. Do you do anything on Halloween (e.g. pumpkins or trick-or-treating)?
5. Do you have any superstitions about: black cats, magpies or spilled salt?

Indeed, as many of us are 'in tune' with our Iron Age roots, walk around any of these fascinating hill forts in the Chilterns and think about who was there, what they might have been doing and how they conducted their everyday life. Only by being there do you get a real feel for this intriguing topic.

Back in the modern town, the inhabitants of Wendover have become a little more civilised since the Iron Age. Following this period, the Romans with their farming villas, and the Saxons and Normans with their settlement and mills, took the village into town status. Wendover has had a Royal Charter to hold a town market since 1464, and this is the only factor making this village-sized settlement a 'town'. Despite being small, Wendover was an important settlement as John Leland reported in 1540 that a causeway had been built to keep the town linked with the larger market town of Aylesbury, as this low-lying clay vale would be prone to waterlogging or flooding in wet weather.

The row of houses called 'Ann Boleyn's cottages' indicates that she once owned the settlement (her father being Lord of Aylesbury Manor). A stroll around the town will reveal these and other ancient history, including houses from the fifteenth century, a canal and old mills (which were recorded here from Domesday time) plus a number of Georgian houses. The enjoyment will also be rewarded by the discovery of the clock tower (a distinctive centrepiece to the town, built in 1842) as well as the modern cafés, pubs and Rumsey's handmade chocolate treats in store for visitors.

At the north end of the Wendover Woods (at SP 888 108) is a BBOWT nature reserve and SSSI (Site of Special Scientific Interest) called Aston Rowant Ragpits. The lumps, bumps and hollows at the bottom of the escarpment reflect the former use of the site as a series of little chalk pits. The quarried material (freestone called chalk rag) will have been used in local buildings. The loose spoil and sheltered hollows have promoted an unusually rich assemblage of plants and invertebrates. Many species may be seen, dependant on the time of year, including red fescue and brome, cowslips, Chiltern gentians, horseshoe and kidney vetches, twayblade and a variety of orchids – frog, bee, fly, fragrant, pyramidal, common spotted, and greater and lesser spotted orchids. As there is a surrounding protective woodland and hedgeline there is also a variety of species associated with these environments. This diversity has encouraged twenty-seven species of butterfly to be recorded in the Ragpits including Chalkhill and Common Blues, and the Duke of Burgundy – each of the twenty-seven species assisted by having the larval food plants present on this small site.

OS Explorer map 181 *Chiltern Hills North.*
Grid refs: Wendover SP864 085 (central); Wigginton Woods SP 933 016 (central).

10

Aldbury

A Journey to the Old Fortification

[From Old English *ald* (old) and *burh* (fortification).]

Ancient holloways, pits and earthworks are all that remains of many thousands of years of human activity in the area around the village. Aldbury is within the National Trust's Ashridge Estate. The estate spreads across the borders of three counties: Hertfordshire, Buckinghamshire and a little bit of Bedfordshire. It consists of 5,000 acres of woodland, chalk downland, common, parkland and farmland.

Ashridge Common is one of 213 commons in the Chilterns. Common land was used for grazing animals, collecting wood and other regional activities, such as gravel or sand extraction, and sometimes when there is clay at the surface this was extracted seasonally for kilns firing bricks, tiles or pottery.

All along the high edge of the Chilterns the settlements are always found at the foot of the scarp, and hence villages such as Pitstone, Ivinghoe and Aldbury are located where springs brought fresh, clear water to the surface. Aldbury is typical of so many of the scarp foot villages ,with picturesque houses clustered around a pond and village green. The medieval stocks and whipping post still stand in the centre, along with the eighteenth-century Greyhound pub.

What would have been the past livelihoods for the people in this fairly remote and small village? The village would have survived on rural industries such as farming and straw plaiting (*see Trail 11: Ivinghoe*). In 1881, the peace of the rural setting was shattered by two murders in the woods at Aldbury Nowers. The area of land in 1881 had hunting rights paid for by Joseph Williams and he employed two gamekeepers, head keeper James Double and his deputy William Puddephatt, to patrol the estate to catch poachers. The men took it in turns to patrol, always with a helper, with Joseph Crawley acting as a night watchman. On 12 December 1881, they set out on their patrol armed with sticks, but never returned. Their battered and blood-covered bodies were discovered the next day and taken to the Greyhound pub to wait for a policeman and an investigation.

The poachers were quickly identified, not surprisingly perhaps in a small community and in a time when few people travelled far. Two renowned poachers, Frederick Eggleton and Charles Rayner, along with Walter Smith, had been seen on the night in question drinking in a number of local pubs – the Britannia in Tring, the Red House at New Mill and then the Bulbourne Arms (by the canal near Pitstone). Earlier that night they had made their way to the Greyhound for a supper of bread, cheese and beer, where they had been spotted by Puddephatt, who had made it his business to see if any suspicious characters were about. It is reported that Puddephatt said to the men, 'We'll meet again', implying he suspected

Above: Fungi is abundant in the Chiltern woodlands in autumn and is especially good on the Ashridge Estate. *(Photograph by John Morris)*

Middle: The village pond in Aldbury. The pond is an essential requirement in every English village, as is the church and the pubs – both always in the centre, where they are the hub of activity and gossip. (*Photograph by Hayley Watkins*)

Below: The old oak on Ashridge Common – a veteran tree, used in many films including Harry Potter and an episode of Jonathon Creek. If you take a close look at the veteran oak, already gnarled from age, you may spot a face looking back at you. Film-makers forgot to remove a spooky dolls head from the trunk when they finished filming a scary sequence in the woods. (*Photograph by John Morris*)

they would be poaching that night. It seems he was proved right. The men were later tried and hanged.

Despite the many uses the land is put to, including recreation, there are a large number of archaeological features preserved around the Ashridge Estate, especially on the common land. These include numerous barrows, mounds, long lengths of earthworks, field lynchets, old clay and chalk pits, Roman enclosures and a kiln site – in fact, ninety-three historic records, including find spots and ancient buildings. However, on the high areas of this estate, permanent settlement was very low over historic times due to a lack of fresh water. Exploring through the woodland and common will reveal several ponds. These are entirely man-made and were for watering animals. Some of them were dug specifically for this purpose and some filled with water after clay extraction. Today these are very important for both their historical and ecological value.

OS Explorer Sheet 181 *Chiltern Hills North.*
Grid ref: a large area centred on SP 975 130.

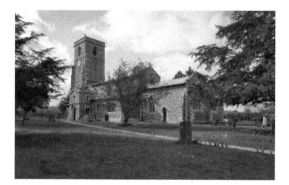

Clockwise from top left: The church, the Greyhound Pub, and the stocks with whipping post in the centre of Aldbury village. Religion, retribution and refreshment all in one place. (*Photographs by Hayley Watkins*)

11
Ivinghoe

A Journey to Iffa's Peoples Spur in the Hills

[From: Old English personal name Ifa, *ingas* (people of) and *hōh* (a spur or promontory).]

(a) The Hills: Incombe Hole to Ivinghoe Beacon

The shape of the hilltop skyline at Ivinghoe from Beacon Hill along to neighbouring Steps Hill has formed by a number of different processes. The skyline is essentially Middle Chalk that has gently weathered and eroded over time to form a scarp edge. Harder beds of chalk, such as the Melbourne Rock, can be seen to stick out as benches in the scarp profile. The softer Lower Chalk is present at the base of the scarp and underlies the villages and beginning of the vale beneath the hills.

Most sculpting was due to Ice Age processes, when the intense cold of tundra conditions formed hollows (coombs) and sinuous dry valleys. A walk from Beacon Hill southwards, taking the main uphill footpath, will pass several coombs (medium-sized depressions along the scarp edge). Further along the path, a dramatic, steep-sided valley is encountered. This is Incombe Hole. This dry valley formed by water flowing on the surface under tundra conditions, while the frozen ground proved impermeable. When the climate returned to temperate conditions, the ground thawed and rainwater now passes directly through the chalk, leaving the valley dry. Explore the valley and note where two water sources formed at the top, providing a forked upper edge. The little horizontal 'steps' in the hillside are soil creep where soil moves gradually down slope every cold, frosty night. This occurs as a result of moisture in the soil freezing and expanding as it does so. The next morning, on thawing, gravity pulls it downwards. After a few years soil can move quite a distance downhill – the Chiltern Hills are wearing away before our eyes!

(b) Ivinghoe Village to College Lake

St Mary's church in Ivinghoe was built adjacent to the Icknield Way in 1220. The Norman effigy in the chancel is thought to be Peter de Chaceport, the builder of the church. In 1234, Richard Siward and a band of local thugs set fire to the village in revenge for a dispute with the landowner, the Bishop of Winchester. Luckily, the church was spared. Like all churches it has had additions and repairs over the years, but the structure mostly makes use of local building stone, such as chalk blocks ('clunch') and flint from the adjacent hills. The cornerstones look much fresher, and these are Portland limestone repairs from Victorian times onwards. This type of Portland stone (from Dorset) was not quarried for export until the Victorian railways made distribution easier.

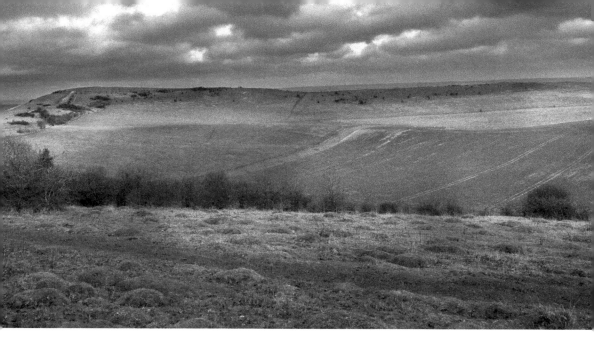

Above: A view to Ivinghoe Beacon and hill fort from the National Trust car park. This is typical chalk landscape, but the flattened top is due to people using it for a multitude of purposes for thousands of years (including use as a ceremonial, burial and settlement site). (*Photograph by Hayley Watkins*)

Below: The town hall, now the modern-day library and shop, but in the past it has been the market and a prison! (*Photograph by Hayley Watkins*)

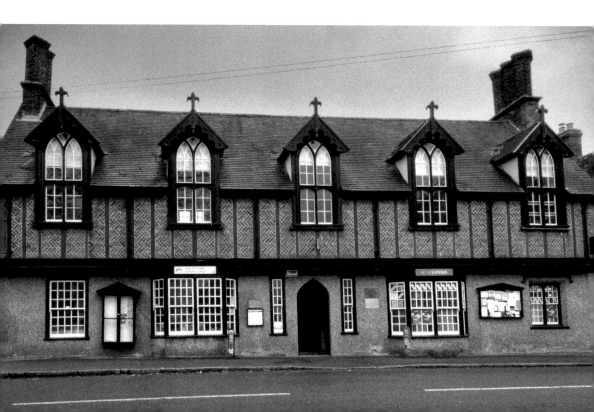

Incombe Hole, a dry valley cut into the chalk scarp at a time Ivinghoe was a tundra environment. (*Photograph by Jill Eyers*)

Inside, the church has many original features. Look out for the pews given to the church by Queen Elizabeth I. The ends are still present and show the local Ivinghoe poppy head design – but also try to spot the witches and the knights, and there is just one mermaid hiding on a bench end. A little fun for the carver no doubt.

The church is next door to a large Georgian building that was formerly the brewery manager's house – the brewery being located behind the house in what is now Windmill Close, but has long since been pulled down. This must have been a noisy corner of the village with the horse and carts entering and leaving the brewery, shoes and wheels clattering on the road surface. The blacksmith was next door (now a private cottage) and the town hall next to that was the site of both the market and the jail. The town hall was built in a mock Tudor style, a common theme in Victorian times. It was abusy market venue, selling all matter of local produce. Of particular importance was the trading in straw plaits and lace making that were the cottage industries of the locals. During the seventeenth to eighteenth centuries, Ivinghoe was very poor. At this time straw bonnets became very fashionable. The pale and fine textured local wheat straw was plaited by local women and children, and the plaits were sold in the market. They were destined for the large hat-making centres in Luton, a trade that lives in the name of the Luton football team – 'the Hatters'.

The Victorian school was in use until the 1960s, when a new school was built, but the building has been in full use since as meeting rooms, and currently as a café. Look around the outside of the building to see evidence of the former Victorian school – you will find deep score marks into the bricks around the entrances and walls, this is where Victorian children sharpened their steel pens to be used with slates.

Walking down the High Street, away from the church and towards Pitstone, a track called Green Lane can be taken on your left. This leads past the windmill and a lovely walk to College Lake can be made this way. (Take care when you rejoin the road over the railway bridge shortly before turning into the College Lake Nature Reserve.) The windmill was built in 1627, and would

have been vital to the village for grinding flour. It was badly damaged in the storm of 1902, which ended its working life. However, it is such an important structure for local history that it was given to the National Trust in 1937, and enough money was secured to start restoration work in 1963 by a group of volunteers.

College Lake is in Marsworth (Mæssa's Enclosure) and the lake now occupies a large hole that was once the site of the chalk excavations by Castle Cement. This is an excellent example of how quarries can be returned to nature at the end of their working life. A walk around the site will be rewarded by a multitude of birds and other wildlife. There are displays with wildlife cameras in place, and a café with plans for a museum in the future. A walk to one of the available hides will also reveal some of the past geological story.

OS Explorer Sheet 181 *Chiltern Hills North.*
Grid refs: Ivinghoe Beacon SP 961 168; hill walk parking (NT) SP 965 159; Incombe Hole SP 960 155.

The Tudor house. There are several Tudor buildings in the village – look for the distinctive beams and brickwork. The old village pump is beside one of them. *(Photograph by Hayley Watkins)*

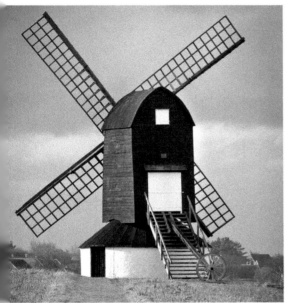

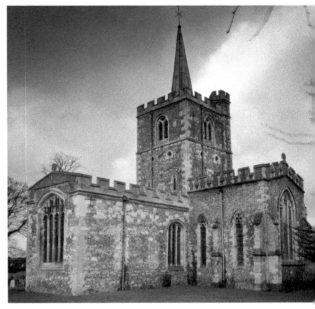

Top: View across College Lake showing the flooded quarry, now a BBOWT nature reserve well known for its birds and other wildlife. *(Photograph by Jill Eyers)*

Above left: The Pitstone windmill. *(Photograph by Hayley Watkins)*

Above right: The church in Ivinghoe. *(Photograph by Hayley Watkins)*

Right: The swirling whitish marks of cryoturbation, where freezing and thawing churns up chalk with soil. Orange-beige ice wedges are where ice has grown into the ground under tundra conditions. *(Photograph by Jill Eyers)*

Top: The Whipsnade Tree Cathedral. (*Photograph by Hayley Watkins*)

Above right: Dunstable Downs, Five Knolls Barrow Cemetery. These Bronze Age burial mounds were put on this high, exposed point 4,500 years ago. Did the place have religious significance, or was it a revered and special place? Perhaps it was a statement to those who could see the white mounds – of ownership or a statement of tribal identity? Mounds such as these were often kept white by pounding fresh chalk onto the surface. (*Photograph by Jill Eyers*).

Left: Whipsnade lion – a modern chalk figure on the scarp. Like other older chalk figures it is meant to be an advertisement and seen from a long way off. (*Photograph by Hayley Watkins*)

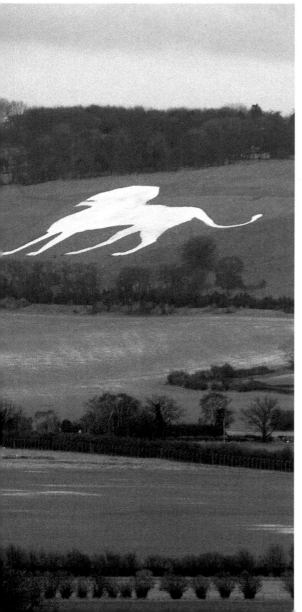

12

Whipsnade and the Dunstable Downs

A Journey From Wibba's Fragment of Land to the Post on the Hill

[From: the Old English personal name Wibba, *snaēd* (isolated piece of land), and *dūn* (hill) and *stapol* (a post or column).]

Possibly best known for its zoo, Whipsnade is a small Chilterns village that could almost be missed due to the multiple centres of activity around it. These include Whipsnade Zoo, nearby Dunstable Downs, numerous footpaths and Whipsnade Tree Cathedral. The cathedral is comprised of 10 acres of garden planted out in the form of a cathedral. The planting was an act of 'faith, hope and reconciliation' by Mr Edmond K. Blythe after the First World War. It was built in 1932 and given as a gift to the National Trust in 1960. There are different trees planted in different sections, with chapels representing the four seasons.

The Whipsnade Downs can be explored from the car park, which will provide panoramic views across the Aylesbury Vale and over to the Ouzel Valley, with views back to Ivinghoe Beacon or to the Totternhoe Knolls. All local history seems to be laid out beneath you: Bronze Age burials, Iron Age forts, Norman castles, medieval churches, rabbit warrens, and drovers' ways. Although parking is available at both locations, the whole stretch of hills from Whipsnade to the Dunstable Downs can be walked easily. This is a good section to try and spot the geology that has shaped such an interesting landscape. The chalk that makes up the backbone of the Chilterns can be seen through worn sections of the pathways, in bank collapses or where rabbits have been digging. Take a look at the chalk rubble that is exposed. It is amazing to think that the white dust that comes off on your hands is the skeletons of many thousands of algae. During the global warming that developed from 95 to 65 million years ago, the warm waters and high sea level promoted blooms of such plankton, the tiny skeletons of which rained down onto the sea floor. There are also lucky finds of other fossils, such as sea urchins, sponges and a variety of sea shells.

Continuing the walk to the end of the Dunstable Downs, it is obvious that the soils are so poor on the scarp edge that early people used the area for purposes other than cultivating crops – as pathways such as the Ridgeway (from the Neolithic period 6,500 years ago), for burials (the Bronze Age, the Five Knolls Round Barrow Cemetery, built around 4,500 years ago), as a medieval warren (for breeding rabbits), as a droveway for pasturing and moving animals, and strip lynchets, which record small-scale farming at the very foot of the scarp. This whole area is steeped with burial tradition as, in addition to Bronze Age burials, there was later use of the same area as a site of mass execution and burials in Saxon times, and later still corpses from the gallows were also buried there.

OS Explorer Sheet 181 *Chiltern Hills North.*
Grid refs: Tree Cathedral TL 006 183; Dunstable Downs TL 010 198 (visitor centre).

13

Sundon Hills to Sharpenhoe Clappers

A Journey from Sunna's Hill to the Steep and Rugged Spur

[From: Sundon – an Old English personal name Sunna with *dūn* (hill), and Sharpenhoe – *scearp* (steep or rugged) with *hōh* (spur of land).]

The area of the Sundon Hills to Sharpenhoe is a continuous, sinuous chalk escarpment north of Dunstable and Luton. It forms the highest point of the Bedfordshire Chilterns. These National Trust sites may be reached off the A6 via Streatley. The area is a good example of chalk landscape, including geomorphological features such as scarp and vale, dip slope, dry valleys and coombs. It is also a good place to see the association between rocks with scenery, soil types and associated nature, which are all intimately linked.

The soils lying directly over chalk are a very different character to those lying directly over Clay-with-flints or over any other residual deposits, such as gravels of glacial origin. There is also till over much of the hills, which is evidence that the Anglian ice covered these hills. The flora can be used to detect the changes in geology. Heath grassland tends to form on the sands and gravels, woodland on any clay areas that are a little richer in humus, and chalk grassland on the thin, chalky soils. The chalk grassland is nationally important for conserving the flora and insects that depend on it. These landscape features need a large area to be seen and appreciated. The chalk (as with all the rocks in Bedfordshire) is only dipping at a very gentle three or four degrees. This is very subtle, but the result is an impressive escarpment and a dip slope representing the topmost bed of the chalk. Here it is around 80 million years old. However, this dip slope is very difficult to see fully as it has been dissected by dry valleys.

The Totternhoe Stone occurs in the sequence just before the break of slope at the base of the hill. This is a famous building stone of the area and is a much harder bed at the top of the otherwise fairly friable Grey Chalk (previously known as Lower Chalk). The Middle Chalk forms the scarp and is present at the top of the hill. Another hard chalk bed called the Melbourne Rock makes a little 'bench' in the middle of the hillside.

Sharpenhoe and Sundon villages, and the famous Sharpenhoe Clappers, are linked by the public footpath system and a circular walk via Harlington can be undertaken (about 7 miles), or shorter walks like Sharpenhoe to the Clappers, which is just 1 mile. The Clappers are well worth a visit as it is the site of one of the chain of hill forts in the Chilterns. The hill fort stands on the top of the plateau, but it is now hidden within beech woodland. The name comes from the Latin *claperius* meaning 'rabbit hole' and they were introduced by the Normans in the twelfth century, becoming very popular by the medieval period. The name of this hilltop has remained due to the rabbit warren being placed there – not a direct naming of the hill fort earthworks. Following the Norman period, rabbits became a large part of the rural economy, with large warrens being set up to farm them for both meat and skins. By the fifteenth century, a rabbit skin would have set you back a whopping threepence in London. The warrens thus became a very profitable business.

OS Explorer Sheet 193 *Luton and Dunstable*.
Grid refs: Sundon TL 048 287; Sharpenhoe TL 065 297; the 'Clappers' TL 049 286.

Below left: The Totternhoe Stone and Chalk blocks of 'clunch' (the more crumbly whiter blocks) in a local church. The clunch might be Melbourne Rock, but any of the hard chalk beds were called 'clunch' by Victorian quarrymen, by virtue of the fact that it made that noise as they hit it with their picks. Look out for this local rock within the older buildings of the surrounding villages. (*Photograph by Jill Eyers*)

Below right: The earthworks at Sharpenhoe Clappers, the remains of the enclosure of an Iron Age hill fort. The Clappers is reputedly haunted. (*Photograph by Hayley Watkins*)

Opposite: Sharpenhoe Clappers. (*Photograph by Hayley Watkins*)

14

Barton-le-Clay

A Journey to Bara's Village on the Clay

[From: Old English name *Bara* and *tūn* (village), with the Old French 'the'.]

When Barton-le-Clay lay on the old coaching route on the London–Bedford–North West England road, it was a hub of activity, with many inns for travellers. Today, it is a much quieter residential village with a very peaceful heart nestled around its thirteenth-century church. It is from the church road that a footpath leads up to the Barton Hills National Nature Reserve. The walk can be magical, taking in a bubbling chalk stream emerging from a natural spring.

Pebbles can be seen lining the bed of the stream. Only chalk and flint are local; other pebbles will have been derived from the glacial deposits that were once on the top of the hill, but not obvious today. They are a glimpse into the cold and distant past – as are those angular, sharp-edged pebbles seen in the river or soil. These will have been broken by the intense cold, and some show pits made by frost-cleaving.

The spring has brickwork around it; remains of a local feud. The Lord of the Manor put in the brickwork to prevent locals using the spring. However, the locals had other ideas, and it was very quickly demolished! The path leads up via 'the Stairway' and allows a view down into the well-named 'Windy Hollow'. This is a particularly well-formed dry valley. The evocative scenery displays many of the geological features expected, such as coombs, valleys, slope failure and soil creep, also seen on other journeys in this book. At the far north end of the nature reserve is an old chalk quarry and benches in the landscape, which are strip lynchets – signs of ploughing by medieval farmers.

OS Landranger Sheet 166. Grid ref: church and nature reserve TL 085 304.

Barton Hills: A view down the Windy Hollow. (*Photograph by Jill Eyers*)

CHILTERN TRAILS: THE PLATEAU AND VALLEYS

15

Nettlebed

A Journey to the 'Nettley Garden Plot'

[From: Old English *netelig* and *bedd*.]

As you look around Nettlebed today, it is difficult to imagine a time when it was anything else but a beautiful, green English village with lush woodland, a patchwork of commons and gentle, rolling hills. Surprisingly, as you walk around the village, and delve into the undergrowth, it is clear that this has been an industrial centre on a very large scale and for many hundreds of years. It also becomes apparent to those with a geological eye, that this has an exceptionally interesting distant past – that is, over a span of many millions of years.

By parking at the end of the High Street, off the A4130 Wallingford–Henley road and near to the common area around Kiln Close, it is possible to take many different footpaths leading to a journey back in time.

The first indication of Nettlebed's industrial past is the name 'Kiln Green', where the large bottle kiln can still be seen towering above the neighbouring houses. This kiln is one of seven large production areas currently known in the immediate area. However, it is also known that the whole of the hillside around Windmill Hill was a mass of small clamp kilns, which were worked as one-man operations. At peak production, the whole of Nettlebed must have been full of smoke, noise and pollution. The earliest written record of production from Nettlebed kilns is for 1365, when 35,000 tiles were made for Wallingford Castle. The cost was not recorded for this load, but it is recorded that in 1390 tiles cost 3s 4d per thousand. The first use of the term 'brick' seems to have occurred around 1416, when Thomas Stonor paid £40 for 200,000 'brykes' from the Crocker End kiln.

The kiln seen at Kiln Green is a late seventeenth-century brick kiln, and it was restored in 1974 after it had been converted to lime-burning use in 1927. The change of use was not surprising as brick production fell considerably after 1906 when an Act of Parliament was

Above left: Nettlebed High Street. (*Photograph by Hayley Watkins*)

Above right: The bottle kiln at Nettlebed was originally an updraught type that could fire up to 18,000 bricks at one time. It was later converted for lime production. The round door in the side of the kiln is the original loading door into the firing chamber. The fuel shed would have been at the back, where there is a stoke hole. (*Photograph by Hayley Watkins*)

Below: Stradwell Pond – an area dug out for clay destined for brick-making in local kilns. Now infilled by water, it is one of many on Nettlebed Common. (*Photograph by Hayley Watkins*)

passed that protected commons. Prior to this, there are records of numerous disputes breaking out where kilns made a mess of both common land and the churchyard.

Brick and tile kilns were always located next to the clay source, which was the most cost-effective way to produce an economical product. Nettlebed's geological past has ensured a thick deposit of top quality clay (Reading beds clay) caps the hills. The quality of bricks made specifically from this clay became renowned and they can be seen in many buildings in Nettlebed High Street and in the surrounding towns and villages.

Walking in any direction along the variety of footpaths crossing the common, or around windmill hill, takes you across this clay deposit. Where it has not been quarried out, the ground is muddy and an orange, sticky clay with coloured blotches may be seen. Where the clay has been dug out, the evidence lies in the sinuous or rounded holes in the ground, which filled with water to become the scattered ponds that are now wildlife havens across the common – a good example is Stradwell Pond.

There is another important part of the geological story visible near the bus stop at Kiln Green – sarsen stones. Sandy types of sarsen were seen in Trails 5 and 18, with their explanation there. These sarsens are pebbly and for this reason are called 'puddingstones' because they resemble the traditional plum pudding served from the late 1700s and onwards through the Victorian period. The two seen here on the common were originally found in the courtyard of the sixteenth-century Bull Inn in the High Street. However, on your exploration of the local woods and common you will find more as they are very numerous.

The odd, scattered occurrence of the sarsen stone has led to many legends. It was often used to ward off evil spirits, and perhaps this is why it is often found as a single foundation block onto which church walls are built (St Mary's in Chesham and St Dunstan's in Monks Risborough are just two examples). They were sometimes called the 'breeding stone' or 'mother stone' as it was believed they grew in the soil. It was clearly the haphazard finding of the stones that created the myths. This is understandable, as early people had no knowledge of the Ice Age or how massive ice sheets once covered the UK and could break up layers of rock.

It was the Ice Age that shaped the valleys around Nettlebed, this time by river diversion. The ancient Thames once flowed across the tops of the hills here, at a time before the Thames valley was cut. The Nettlebed gravels are known to be the oldest of all the Thames deposits. A walk northwards around Priest Hill will reveal the highly rounded evidence in the form of white and coloured quartzite and flint pebbles in footpaths. After this time, the River Thames has gradually cut its valley down to the modern level, but it is now 8 kilometres away. All British rivers cut down their valleys during the Ice Age, prompted by the fall in sea level (base level) during each big freeze.

At the same time, it was the effect of the intense cold of the tundra environment during the glacial periods that broke up the sarsen blocks to produce the large boulders seen across the landscape today, and which people have used as a resource ever since, whether as building stone, querns for grinding wheat, or boundary markers.

Map: OS Explorer 171 *Chiltern Hills West* 1:25,000.
Geological map: British Geological Survey. Sheet 254 *Henley-on-Thames*.

16

The Hambleden Valley

A Journey Though the Crooked Valley

[From: the Old English *hamol* (crooked) and *denu* (sinuous valley).]

Hambleden is a small Chiltern village located just north of the River Thames between the towns of Henley and Marlow off the A4155. It is a charming valley, full of character, and it has been the location for many historical films. The village lies in a dry valley of the Chilterns, the sinuous nature of which is marked by the Hamble Brook.

The Hambleden Valley is cut into Middle and Upper Chalk (the Lewes Nodular Chalk, the Seaford and the Newhaven Chalk Formations). This has provided the source for some of the building materials both seen today in the older buildings and the church for instance, and also in the past, in the Roman villa construction. The Thames Valley has cut down into the southernmost section of the dry valley (the river cutting through approximately east–west here), with the Hamble Brook occupying a north–south orientated dry valley cut during the Quaternary period. The highest points are the hilltops flanking the valley at up to 115 metres, and the lowest point is at 32 metres on the banks of the Thames. On the hilltops, such as on Ridge Wood on the west side of the valley, there are sandy gravels (called the Beaconsfield gravels, which were laid down by an ancient Thames, before it cut down into the present lower valley). On the eastern hilltops, there is the Gerrards Cross Gravels, deposits of the ancient Thames from the Ice Age.

The area is predominantly agricultural, being divided between two estates: Culdenfaw and Hambleden. Farming is mixed arable on the lower slopes to grazing (mostly dairy cattle, with some sheep) on the valley bottom. The stream has been prone to flooding the pastures in the past and was particularly bad during the wet winter of 2013/14, but in recent years it has been prone to drying up. The stream was diverted from its original position during the mid-1860s as part of the enclosures and other boundary changes. The hilltops are wooded and maintained in parts for sustainable tree felling, in other parts for game rearing. Public footpaths provide access to many parts of the lower and upper valley and all paths lead to beautiful walks.

There are two Roman villas within the valley and these are in an unusually close proximity. As villas were working farms, they are usually found at intervals in the countryside with their fields and woodland around them. However, arable land is restricted in the Hambleden Valley due to steep slopes and the flood meadow with the Hamble Brook. The clue for Roman livelihoods in this valley lies in the close proximity to the River Thames. The river would have been the main arterial route for trade coming in from Gaul through London and making its way to inland markets such as Dorchester-on-Thames up river. However, with a shallow point in the river at this point, it is likely that at some time of the year trade had to disembark and

make its way cross country, past Bix Roman villa and on via the Fairmile – a well-known Roman road. At least one of these Hambleden villas must have been involved in managing the river trade. It is clear they became wealthy very quickly after the Roman army invasion – very likely collaborating with the army.

The Anglo-Saxons were present in the valley as they named the village, as well as many of the surrounding villages. However, the precise site of their settlement has never been located and no finds have come to light as yet. However, there is reported to be a Saxon font in the Norman church.

Walking around the village, houses with wooden frames dating to the fifteenth century onwards may be seen, as well as the Jacobean manor house. Early workers' cottages dating to the seventeenth and eighteenth centuries show the traditional Chiltern building style of brick with flint.

OS Landranger sheet 175 or OS Explorer Sheet 171 *Chiltern Hills West*.
Grid ref: Hambleden SU 785 866 (village car park).

Right: St Mary's church in Hambleden. A Norman church but with much of the structure built in the fourteenth century, with the tower dating to 1721, and substantial renovation in 1883. (*Photograph by Jill Eyers*)

Above: The Hambleden valley looking south. (*Photograph by Jill Eyers*)

Below left: Eighteenth- to nineteenth-century workers' cottages. (*Photograph by Jill Eyers*)

Below right: Saxon font in St Mary's church, Hambleden. (*Photograph by Jill Eyers*)

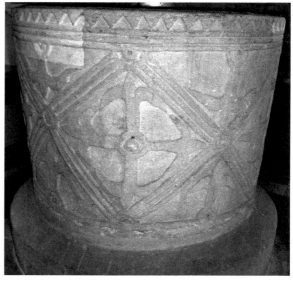

<div style="text-align:right">

17

</div>

The Chiltern 'Ends'

A Journey Through the Meres at the Parish Ends

[Cadmore End from Old English personal name Cada and *mere* (a pond or wet area). The previous spelling (in the 1500s) was Cadmerende; Moor End from *mŏr* (Old English) or *mór* (Norse), both meaning marsh or barren land; Lane End, literally the lane's end. The other 'ends' are personal or crop names.]

There are a number of 'ends' in the Chilterns, notably at the southern end – Crocker End, Water End, Cadmore End, Moor End, Lane End, Bolter End, Wheeler End and Turnip End, to name just a few. The name has come about as an addition to an original name where there is literally an end to a strip parish. Strip parishes are long and very thin parishes (they can be up to 8 miles long) stretching from the clay vale beneath the hills, rising up a portion of scarp to the dip slope at the top, and often incorporating a section of dry valley at the named 'end'. This system was set in place from Anglo-Saxon times onwards and was designed to give a parish as much self-sufficiency as possible. It did this by including many different land types from clay arable to spring line, downland, scrub and woodland areas, with the potential for open fields and even more arable land on the dip slope. In doing so, a number of different crops could be grown and there was provision of land suitable for cattle (meadows), sheep (downland) and pigs (traditionally kept in woodland). This would include good opportunities for foraging for wild food and firewood. The 'ends' were the last tip of the parish on poor soil and on the hilltop. They were very often used as common land, where seasonal cottages were the only settlement, and they were poor areas of shabby houses, where people struggled to make a living. Today, the ends have developed into lovely Chiltern villages, highly sought after as very pleasant places to live.

Moor End and Moorend Common have unusual geology, which has provided an unusual mix of clay and sands at the surface within an otherwise chalk landscape. The geological structure is what is different for the common, and this comes in the form of a graben. This is a segment of crust surrounded by faults. Fault movement (a past earthquake) resulted in a chunk of land under the common dropping down along these fractures. This has preserved a segment of the London Clay and Reading beds providing clay for a thriving brick and tile industry, as well as unusual sandy heath, plus marsh and acid grassland for which it has been designated as an SSSI (Site of Special Scientific Interest). There is also a very large swallow hole (known as 'the Sinks' or 'Gubbins Hole'), where the tiny stream flows into the hole and disappears.

Moorend Common actually hides a little secret, and one that even very few of the locals seem to know about. This is actually the location for the lost village of Ackhamstead (located around SU 807 907). The name means the 'oak homestead', and indeed the oak trees are still to be found

around this area, as is the ruined remains of their church. This village is mentioned in documents dating to 1242 as having been owned by Abingdon Abbey in Saxon times (1052). The church dated from around the thirteenth century, and until the early 1800s it was a thriving rural community. But treachery was afoot. Why did their vicar call them a 'heathen bunch' when there was a regular attendance of eighty to ninety people in the tiny chapel? It is not certain, but shortly afterwards, at a meeting in 1847 held by the Cadmore End residents, it was decided that Ackhamstead church would be demolished and the stone used to build a church at Cadmore End. The Ackhamstead residents were told to worship at the church in Frieth! It seems they had no say in this matter.

Local people used to mine the clay from the common at Cadmore End and use it in the thriving brick industry here. This is evident from the many pits and hollows over the Cadmore End common, some now filling with water as ponds.

As a point of interest, nearly all the place names in this area are from Anglo-Saxon origins, with only minor input from Roman or Norman influences. Significantly, there are three Norse (Viking) names close by: Frieth, Fingest and Skirmett. Frieth comes from the Norse word *fyrhth(e)* meaning 'scruffy wood'. *Fingest* means 'cleared of trees by burning' and *skirmett* is Norse for 'the shire meeting place'. Norse names in this area are out of place and therefore intriguing. Where did these early villagers come from and why? It is just a suggestion, but not proven, that this group of people may have fled from Oxford in the tenth century. It is well documented that the Anglo-Saxon dominated Oxford had a significant Norse population. At this time it is also documented that, in a knee-jerk response to Viking raids on southern England, the Norse community were rounded up, locked in St Michael's church in Oxford and the church burnt down, killing all occupants. The suggestion being that some may have fled and the nearest safe place for those fleeing south-east would be the heavily wooded Chiltern Hills.

OS Explorer map 171 *Chiltern Hills West*.
Geological map BGS sheet 254 *Henley-on-Thames*. 1:50,000 scale.
Grid refs: Moorend Common SU801 906 (central); Cadmore End SU 785 925; Lane End SU 810 920.

Right: Lane End pond. (*Photograph by Hayley Watkins*)

Below: The Glade at Moorend Common. Not to be confused with rivals Moor End just to the north, where there is another small common. (*Photograph by Katy Dunn*)

Opposite: Wheeler End Common, the chequers. (*Photograph by Hayley Watkins*)

The boundary bank on Moorend Common. This is a very ancient bank forming a land boundary between woodland and animal grazing areas on the common. There are a series of earthworks, old quarries and holloways that people used over many centuries as they went about their everyday lives collecting firewood and gathering wild food, along with grazing their animals.

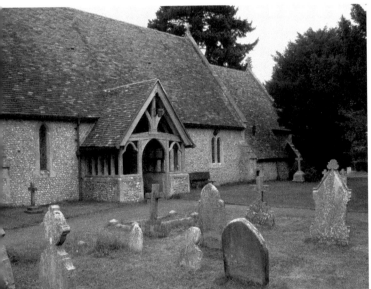

St Mary-le-Moor church, Cadmore End, where the Ackhamsted church ended up! The flint and minor sandstone cobbles were removed from the demolished chapel at Ackhamstead, which became a deserted village soon afterwards. (*Photograph by Jill Eyers*)

The pond at Cadmore End Common. (*Photograph by John Morris*)

<div align="right">18</div>

West Wycombe to Bradenham

A Journey from the 'Wye' Valley to the Broad Village

[From: Old English, where west means 'west', but there is a dispute whether the 'Wye' comes from the present name for the River Wye flowing through it or if the river became named from the place, which in that case could be *wic* and therefore either a dairy farm or trading hamlet. There is no dispute for Bradenham: *brād* (broad) and *hām* (village or manor).]

The points of interest for this journey may be reached by car, but exploring them makes an interesting walk, although it will need more than two hours to complete the circular route. The best place to start this journey is to park in the St Lawrence's church car park (National Trust) at the top of the hill (access is via the minor road signed from the A40 as 'The Caves').

The church and mausoleum should be viewed first and then, on leaving the church, return through the exit on the north side, keeping to the left side of the car park, and west of the house after this point. Walk along the Bledlow Ridge footpath to Hearnton Wood and Nobles Farm. At Nobles Farm, take the right-hand footpath to Bradenham, passing under the railway. Cross the A4010 Bradenham Road and walk through Bradenham to St Botolph's church on the right. After St Botolph's and the Green, turn back in the A4010/Red Lion direction, but before this point turn left and walk up the lane to the other side of the green (the cricket pitch). This leads to the A4010 near the Old Rectory, where you will turn left for only around 150 metres before taking the right-hand path to Averingdown Farm. Keep on this path until you come to the path you walked out on. Turning left here takes you back to St Lawrence's church and the hill fort. If you would like to visit the West Wycombe caves, follow the road to the left as you reach St Lawrence's church car park, veering right along the lane and not directly on through to the buildings in front. The caves will be on your right.

The Mausoleum, Iron Age Hill Fort and St Lawrence's Church

St Lawrence's church is on top of the hill and displays the local landmark of the golden ball in the tower. The church is Norman, but the building was altered considerably for Sir Francis Dashwood, when the golden ball was added to the tower, thus becoming a notable local landmark.

The church uses local building materials, mostly flint with two types of sarsen, the sandy and the pebbly (puddingstone) types. The sandy type is known locally as Denner Hill stone (obtained usually at Naphill or Walters Ash). This exceptionally hard stone can be found in many town and village centres across this part of Bucks. The pebbly sarsen is very distinct

Above: View of the mausoleum with the golden ball and St Lawrence's church on the hill at West Wycombe. (*Photograph by Hayley Watkins*)

Below: Although the building of the mausoleum in the 1700s damaged part of the ancient earthworks of the original hill fort, it is possible to clearly trace the bank and ditch around most of the site. (*Photograph by Jill Eyers*)

and called the Bradenham Puddingstone. The gravestones also contain a variety of rock types – granites, sandstones and limestones are among the most common.

The church, the graveyard and the mausoleum all lie within a circular hill fort of almost 3 acres. Pottery and other finds indicate that this was inhabited during the early Iron Age around 2,500 years ago. Although damaged by the building of the church and mausoleum, the bank and ditch of the defences are still very dramatic on the south-west side.

The mausoleum was built in 1763/64 with a bequest of £500. It was inspired by Constantine's Arch in Rome and was built for Dashwood's first wife, now housing the remains of many family members. Local building materials such as large amounts of flint (undressed and knapped) were used, as well as Portland stone from Dorset. Note the native yew trees around this area and along the ridge.

The Dry Valleys

Looking south-east towards High Wycombe from the mausoleum gate, the view is a wide valley carved by meltwaters during the Ice Age. The road system today was once the path of torrential flow from melting ice and snow. The water flowed down what is now the A40 Oxford Road and this was joined by flow from the A4010 Bradenham Road from the left. This dry valley is only one of many cut into the chalk of the Chilterns, and indeed shapes the beautiful Chiltern landscape.

These valleys were cut at a time when the porosity of the chalk was blocked by ice – frozen rock will not let water pass through it. Meltwater that formed at the end of glacial periods ran over the surface as rivers, cutting valleys as they flowed.

To take the walk to Bradenham, the track leads out from the north gate of the church to Bledlow Ridge and into the woods. This high strip of land rises to 180 metres, towering over the incised valleys either side – a ridge of rock left behind after the meltwaters had cut down into the solid chalk! The bare chalk can often be seen through the very thin, pale soils of the slopes and in the valley. There is a capping of Clay-with-flint on the hilltops in this area (hence it is often muddy after rain along the ridge). The clay plus the large amount of flint it contains ensured this was never suitable for arable use and this is the reason why the Chiltern woodland occurs predominantly on the tops of the hills, not in the valleys.

The footpath descends to cross the A4010 road just short of the Red Lion pub and then on into Bradenham village. On either side of the valley, the hard Middle and Upper Chalk slopes rise steeply. The valley bottom and sides at Bradenham are littered with sarsen stones. One of them is the famous pebbly type known as the Bradenham Puddingstone. It can be seen more easily as loose blocks around the cricket pitch and grass area in front of the church. However, fresher blocks can be seen in surrounding fields and throughout the woodland.

The sarsens represent the sand and gravel laid down in an ancient river deposit. They have turned into a rock called silcrete, which forms in semi-arid climates today. These are dated to *c.* 50 million years old, when Britain was experiencing a much warmer climate.

This is a very tough rock consisting of quartz sand, rounded flint and quartz cement. As quartz is one of the hardest minerals, any rocks made from it are very hard and resistant to weathering. It is difficult to imagine how it might have been broken up and moved from its original location at the top of the hill. This problem was one of the great mysteries for geologists for hundreds of years. None of the sarsens are in the place they were originally laid down,

although they may not be far from it. Originally the blocks formed one large and continuous outcrop, but due to freeze-thaw activity during the Ice Age the rock became fractured and, as the dry valley was cut by meltwaters, the blocks simply sludged their way down-slope (a process called solifluction [*see Trail 5: Aston Rowant*]). They have stayed there ever since.

St Botolph's Church

The church is dedicated to St Botolph, the patron saint of travellers. The building stones used in the construction are nearly all local. Flint is used both in the undressed and knapped form – undressed in the older areas (such as the twelfth-century nave and the fifteenth-century tower) and knapped flint in the nineteenth-century porch. Flint is abundant in the local area and is common in older buildings, often teamed up with 'clunch', which is a hard bed from the chalk, or sometimes local Portland stone was used. However, the Portland stone seen in the large repaired blocks of the cornerstones is not the local type but has been brought in from Dorset. These are no doubt Victorian or more recent repairs. Look closely and you can see lots of tiny spheres of calcite called 'ooliths' and also lots of broken shell. The local variety of Portland stone is a darker colour (a mid to dark beige) and often has a poorer cement.

Local sarsen is also used in the building – the 'sugary' textured sandy one (Denner Hill type). Although the sarsens are abundant locally, the stonemasons did not choose to use them and this is no doubt because they were too hard. Sarsens used for building have to be worked soon after digging out of the ground. Those at the surface are hugely tough to work and are only used whole, often as a base to part of the foundation wall.

The Manor House

The Manor House, next to the church, occupies a prime position overlooking the valley and village. This was the childhood home of Benjamin Disraeli. It is now a management centre, but sometimes opens its doors to the public for the National Gardens Scheme.

The Caves

The caves were cut by the Dashwood family during the years 1748–52. The quarried chalk went into the construction of the A40 West Wycombe to High Wycombe road. The caves then served as a meeting place for Sir Francis Dashwood's club, which became known as the 'Hellfire Club', although Dashwood himself would have been horrified at this name, and he called the club the 'Knights of St Francis of Wycombe' or 'Dashwoods Apostles'. They met twice a year and devoted their time to drink and women (which is why it earned the local name of the Hellfire Club). There is a tour around the caves that are open to the public.

OS Explorer map 172 *Chiltern Hills East*.
Grid ref: West Wycombe SP 825 948 (car park).

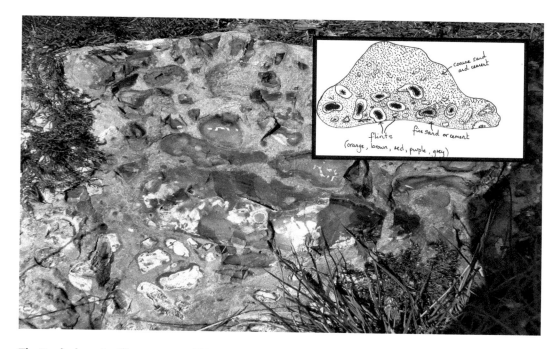

The Bradenham Puddingstone, a pebbly sarsen stone of which other types may also be found at Nettlebed, Chesham, Hambleden and Cholesbury. This shows quite clearly the pebbly sarsen gradually changing to the sandy type in the same deposit. This is just one piece of evidence to prove the river origin for this rock 50 million years ago. (*Photograph by Jill Eyers*)

St Botolph's church constructed from local building stone: grey sandy sarsen and flint, and one pebbly sarsen block to fill in a gap! (*Photograph by Jill Eyers*)

19

Hughenden to Downley Common

A Journey from Hycga's Valley to the Clearing on the Hill

[Hughenden: from the Old English name Hycga and *denu* meaning 'sinuous valley'; and Downley: from *dūn* meaning 'flat topped hill' and *ley,* a clearing in woodland.]

The best way to explore Hughenden and Downley Common is by a 2.5-mile (4 km) circular walk. This is a pretty area with lots of history, geology, woodland and common land.

A good start is from the parking area for Hughenden church and manor off the A4128 in the Hughenden Valley (free parking is available in front of the church). Hughenden Manor is a famous National Trust property and the Stables Tearoom is a good stop for refreshments or there is also the Le De Spencer Arms on Downley Common.

To keep walkers on the straight and narrow here is the route, linked to the numbered information points explained below: from the entrance (1) the walk takes the uphill path past the church and cottages on your right (2), past the rear entrance of Hughenden Manor (4), and through the woods (5) towards Downley Common. Ignore alternative paths on your right, walk past Well Cottage (6), and keep straight on via Moor Lane to the road around the common (7). The walk then goes clockwise along this road, past the Old Forge (8). Follow the roadway with the cricket/football pitch remaining on your right. At the T-junction with the dirt track, the route goes right, but an interesting diversion can be taken to your left. If you turn left along this track, past the grassland and the Le De Spencer Arms (9) towards Hunts Hill, you will soon see the 'Dells' (10). The walk could continue into Naphill Common for the keen walkers. Refreshment can be gained as you return to the pub before following the track back to the main route (note grassland areas on your right with distinctive and varied wildlife), and turning left past the grand holly hedge, on past the white house, through a gate, turning right to follow a narrow path downhill to Common Wood (11) and another gate. Through this gate, turn left to see two white arrows on a tree, follow the right arrow, walk through the wood until you meet a crossing with another path. Turn left here and continue over a chalk ditch (12). Ignore another white arrow and keep downhill on this path until you reach a broad crossing track. Go straight over this track and uphill to where it joins another path at the top. Turn right and follow the path as it contours around the hillside. Continue straight on through the wood to eventually join up with the path near Hughenden Manor, which was the start point. Leave enough time to visit the manor – the home of Benjamin Disraeli (1804–81) who was twice a British Prime Minister. The trail interest points are as follows:

1. There is a little stream at the entrance to the manor and church grounds, near the main road. It looks remarkably small and shallow considering Disraeli once caught a 4.5lb trout there!

The little chalk stream within the Hughenden Valley. (*Photograph by Hayley Watkins*)

2. Hughenden church

St Michael's is a fourteenth-century church that was remodelled during 1874–90. Both Disraeli and his wife are buried there (within the blue fenced area). Queen Victoria arranged the monument to Disraeli after his death.

3. Hughenden Valley

This is a valley carved from the chalk during the Ice Age (it is much too big to have been carved by the little stream currently running through the valley). The valley would have formed during each of the three major glaciations affecting landscape in Britain during the Ice Age, from half a million years ago. During these times, the ground became frozen (permafrost) and during the subsequent thaw, water suddenly flowed over the surface and could become a torrential flow. The effect was to cut down a wide river valley, as pores within the underlying chalk would be frozen, blocked with ice. Today, most of these valleys are dry, except for where they intersect the water table and small, misfit streams run along them. Imagine the Hughenden Valley as it was 14,000 years ago – no grass, no trees, torrential water at the bottom of the valley, with tundra scrub and lichens in patches on the hills, and herds of mammoths and woolly rhinos grazing on the slopes!

4. Hughenden Manor

At the time of the Norman Conquest, Hughenden Manor was granted to Odo, the Bishop of Bayeux. It has gone through a number of wealthy hands, including being handed to the Dormers by Henry VIII during the dissolution in 1538. It was the home of Benjamin Disraeli

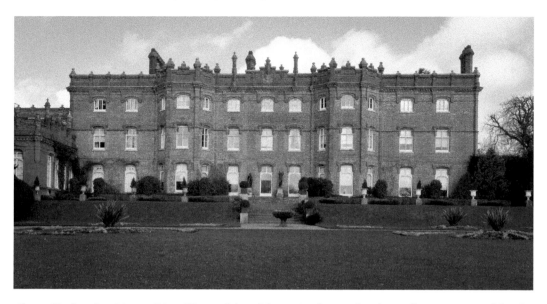

Above: Hughenden Manor, Disraeli's much-loved home in the Hughenden Valley, now owned by the National Trust. (*Photograph by Hayley Watkins*)

Below: The Old Smithy: The blacksmith's forge, one of several past professions on the common. The bricks are hand-made older types. Were they the product of the kiln next door? (*Photograph by Jill Eyers*)

and his wife for thirty years. The Disraelis loved Hughenden, particularly enjoying the golden colours of the oak and beech woodland in the autumn. It has recently come to light that during the war the manor was the mapping centre for the RAF Bomber Command in the charge of 'Bomber Harris'.

5. Oak woodland

An oak tree can live for almost 1,000 years, and they take about 300 years to reach full size. Oak trees grow an average of 1 inch each year, so measuring the girth of an oak tree is a good indicator of age – a tree measuring 100 inches would be 100 years old. A quick way to work this out on a walk (with no tape measure) is to get everyone in your party to hug the tree – who can hug the tree with their fingers just touching on the other side? Whoever this is, if they know how tall they are then this is the girth of the tree. (For instance an average woman is 5 foot 6 inches, or 66 inches, and so is her arm circumference. A tree fitting this arm length would be sixty-six years old).

The trees in this area are not part of ancient woodland, although there are a few up to a couple of hundred years old. Much of the woodland shows evidence of replanting from the 1800s onwards on both the Hughenden and the Downley side of the manorial boundary (the boundary is marked by the big bank and ditch crossed on the footpath leading into Downley).

The oak trees are the whole focus for wildlife in these woods. They provide shelter, food and a microenvironment for other species. In summer, they form a broad canopy providing deep shade where only shrubs and herbs grow beneath. Look for the wide variety of wildlife to be seen within the brambles, and in late spring look out for the pretty woodland flowers such as wood spurge.

The Hughenden Manor side of the deep boundary ditch is all oak woodland, but the wood changes dramatically on the Downley side (which is part of the West Wycombe manorial estate), as here it has been planted as beech woodland. The woodland immediately surrounding the common has only grown since the Second World War (aerial photos of this time show open fields in what is now a relatively well-developed wood. Walking in the woods today there are areas where deep furrows can be found. These were caused by tanks that were being tested over the common, having been secretly repaired at the Broom & Wade furniture factory nearby. Older gentlemen in the village recount that walking home from school used to be great fun as they sometimes got a lift home in a tank (against regulations), indicating that this was not the best kept wartime secret!

6. Well Cottage

This cottage was built in 1813. It was vital to the villagers living around the common as this was the only well that never dried up, even in the most severe of droughts.

7. Downley Common

The common has a wide range of wildlife habitats ranging from grassland to scrub, hedges, woodland and wetlands. Among the grassland there are distinct types – hay meadow (with neutral soils such as that opposite the Le De Spencer Arms), coarse pasture (nutrient-rich and in summer adorned by rosebay willowherb), acid grassland (with gorse, bracken, heather and catsear), woodland grass (seen as you enter Common Wood), and wetland grass (found close to Naphill Common).

8. The Old Smithy
The Old Smithy is one of the oldest buildings around the common (along with the Le De Spencer Arms and the cottage). These buildings are all marked on a West Wycombe Manorial map of 1767. The smithy was used as a blacksmith's forge until the 1990s and is now used by the cricket club.

9. Le De Spencer Arms
One of the oldest buildings around the common, and it is also on the 1767 map. In the past the pub has been a bakery, a grocer's and an inn. In the summer of 2005, mysterious holes opened up within the grassy areas beside the car park at the rear. Could these be old cellars, a cesspit, or some other structure? They were not investigated, but still lie beneath the surface.

10. The 'Dells'
The local name for the myriad of small depressions (pits) seen on either side of the track walking towards Hunts Hill. Only go as far as the large fallen tree in the centre of the path. These pits are old workings for the clays that went into the brick kiln on the common. The clays belong to the Reading beds – top quality clay. This kiln had been demolished by the early 1800s, but the remains are thought to be under the road next to the cricket pitch and dirt track. During 2005, a group of children from Downley School helped excavate six areas within the dells to discover their history as part of a lottery funded project. Wartime items such as hobnail boots, tank parts and Shipham's fish paste jars were items of fascination to the youngsters, and showed rubbish disposal used some pits on the common.

11. Beech Woodland
This part of Common Wood is typical of the Downley side of the woods. There are lots of examples of coppiced trees where the common has been managed for wood fuel in the past. Commons have always been a hive of activity for grazing of animals, collecting firewood and other foraging for wild berries, fungi and nuts, as well as a place for industry. Many commons have clay, chalk or gravel extraction pits, and a good number of commons have brick kilns. The presence of kilns is being proved more and more with archaeological investigations. The historical evidence would be difficult to gain by census returns, as the profession of a brick-maker was very low status. For this reason, and as it was seasonal work, people recorded their 'other job' as their profession, which was often an agricultural worker.

12. The manorial boundary ditch has been here for many hundreds of years and still forms an important parish boundary today. In the days of the manorial system it was very important to keep your boundary marked to stop any encroachment by neighbouring estates, who may wish to help themselves to your wood, game or other amenities of the forest.

Map: OS Explorer 172 *Chiltern Hills East* 1:25,000.
Geological map: British Geological Survey. Sheet 255 *Beaconsfield*.
Grid ref: Downley Common SU 848 960 (central point); Hughenden Manor SU 862 954.

Opposite: The Dells: The local nickname for the undulating ground with sinuous depressions in the present woodland. These were once the site of clay extraction for a kiln producing local bricks from the 1700 to 1800s. (*Photograph by Jill Eyers*)

Rosebay willowherb on the coarse pasture. (*Photograph by Jill Eyers*)

Le De Spencer Arms. In the past, it has been an inn, a baker's, a grocer's, and currently a good watering spot for walkers and locals. (*Photograph by Jill Eyers*)

20

Great Missenden

A Journey to the Mossy Valley

[Probably derived from *mēos* and the noun *mysse*, which means 'mossy', and *denu* (a sinuous valley) both from Anglo-Saxon.]

The best way to explore Great Missenden is by a 3-mile (5 km) circular walk around the village and then to stop and enjoy some refreshment in one of the several pubs and restaurants, or at the Twit's café with a visit to the Roald Dahl Museum in the High Street. The route described here is planned to show some of the hidden delights of the Misbourne Valley – over the chalk hills and through the valley pointing to the clues that unravel some intriguing geology, archaeology and history.

The start point is the same whether arrival is by train (Great Missenden station is very close to the start of the walk) or by car (leave the A413 at the Great Missenden roundabout, continue about 200 metres down Link Road to the signed car park). The best walk route leaves the rear of the car park and at the first stile note the grey sarsen stone. Feel the rough texture of quartz grains. Sarsens are found across many English counties and the Chilterns has many such stones (see Nettlebed and Bradenham). Their name comes from a corruption of *saracen* meaning 'stranger in a field', and that is just how you find them – isolated stones that are scattered across fields and woods.

Note the stream. The Misbourne is a typical chalk stream and an internationally rare wildlife habitat. Some years it dries up completely and other years it flows with clear, sparkling spring water. To understand why, you need to consider that although chalk is a fairly hard rock, it acts like a sponge and holds water, gradually filling as it rains (an aquifer). It will dry up when the level of the water table falls below the ground surface. This could occur by over abstraction for water supplies as much as low rainfall. Note the cut the river has made in the past and note the sands and clays you will be walking over, which are the floodplain deposits of wetter times.

If the walker follows the water flow upstream (northwards), then Mobwell Pond is reached opposite the Black Horse pub. This is the source of the Misbourne stream produced by a spring of clear, fresh water. It tends to flow from here only in winter after rain. Streams like this are called 'winterbournes'. Even when dry, the alder trees and sedges show water may not be far beneath the surface as these trees are commonly close to water and thrive within marshy areas.

Go through the gate and over a railway bridge taking a left-hand path back to see the lovely view of this typical Chiltern landscape of rolling green hills and beech woodland. Cross Rignall Road and keep to the marked public footpath to cross Martins End Lane and into Angling Spring Wood. This is mixed ancient woodland that is rich in beech.

This woodland was Roald Dahl's local woodland and the place to find the 'Witches Tree', which inspired the story of *Fantastic Mr Fox*. This tree is now on the ground, having been blown

Above: Missenden Abbey from the bridge over Warren Water. (*Photograph by Jill Eyers*)

Below: Beech woodland in Angling Spring Wood. It is easy to see how Roald Dahl found inspiration for his books in his local woods. (*Photograph by John Morris*)

Previous page: Mobwell Pond, the source of the Misbourne stream. (*Photograph by Hayley Watkins*)

down in a gale during 2003. The wood is home to a vast range of plants and animals, not just foxes, and it contains rare slugs and fungi. There is a spring within the wood and you can sense when you get near – the air feels cool and damp even when there is no surface water. This eerie feeling may have fuelled some characterisation in Dahl's books. The woodland path goes round to the left and back towards Missenden, where you pass the George Inn.

The George Inn was built in the fifteenth century and is the oldest inn in the village. The London Road running past it was once the main route to and from London. This was one of numerous coaching inns on this road. The George became very important as it was also the site of the court house. Turn right onto the London Road, this will take you to the public footpath route over Warren Water, where you can look across the vista towards Missenden Abbey.

Warren Water formed part of the garden landscaping by the Oldham family at the end of the eighteenth century. The lake only fills during the wettest times of the year, and dries out during the years that the Misbourne fails to flow. Missenden Abbey can be seen across the lawns from the bridge. This is an elegant rebuild, following the massive fire in 1985, but small sections of the original building may still be seen. The abbey was originally founded in 1133 for Augustinian canons. It is recorded that in the early 1200s there were a fair number of suicides among the novices; the reasons were never disclosed, but hints at foul play from within. The abbey was dissolved in 1538 by Henry VIII, and this began a long history for the building as a country residence for wealthy families, starting with Richard Drury of Chalfont St Peter.

The steps at the end of this path lead up to the church of St Peter and St Paul. This medieval church shows use of common local building stones. Look out for local rocks: cream-white 'clunch' (chalk rock); blackish and mottled flints, locally made cement, and even reused Roman roof tiles. The beige blocks of Portland limestone are newer repairs bringing rock from Dorset from the Victorian period onwards, as local rock was no longer available. The minor road downhill to Frith Hill returns to the centre of the village.

Map: OS Explorer 181 *Chiltern Hills North* 1:25,000.
Geological map: British Geological Survey. Sheet 238 *Aylesbury*.

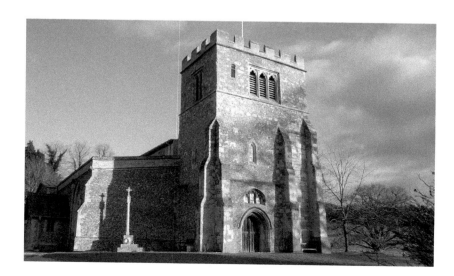

St Peter's and
St Paul's church,
Great Missenden.
(*Photograph by
Jill Eyers*)

21

Cholesbury

A Journey to Ceolwald's Fortification

[From: Old English personal name Cēolweald and *burh* (fortification).]

Cholesbury lies to the east of Wendover and is well within the plateau area of the Chilterns. It lies on a mix of geological formations, including Clay-with-flints and various sarsens and gravels over chalk. The predominance of the clay means the soil is heavy, but retains water. This is just as well, as running water is scarce in this region.

The fortification referred to in the Anglo-Saxon name is the Iron Age hill fort, which unusually lies directly in the centre of the village, next to the village green. The church of St Lawrence's and several field enclosures all lie within its 6 acres. It has a dew pond within the significantly large earthworks. The dew pond has been dug into the clay and today it provides water for livestock. If the dew pond is contemporaneous with the hill fort, then it could have provided water for the Iron Age inhabitants. Indeed, this is one of the rare hill forts that we do know something about, and in 1932 an excavation proved middle Iron Age to very late Iron Age 'Belgic' pottery. There were also several hearths discovered as well as signs of iron smelting, probably small metalworking activities. People were definitely living within this enclosure, but it is a lot younger than other hill forts known along the Chiltern's chain, which can be up to 800 BC (Ivinghoe).

The village was recorded in the Domesday Book was valued at £5 and later it appeared in thirteenth-century records as 'Chelwardisbyry'. It seems to have always been a small village with a poor community living there, existing on the common edge.

In the late 1640s, like many parts of the Chilterns, there was local discontent on the levying of Ship Money tax at inland locations and, with other factors, caused disputes between Parliamentarians (the Roundheads) and King Charles I (the Royalists). As King Charles continued to try to rule without parliamentary support, Parliamentarian troops were billeted in Cholesbury and other Chiltern villages during the English Civil War. From Cholesbury they took part in skirmishes involving Prince Rupert at Chesham and Wendover.

The village is on the route of several drovers' ways and offered grazing and water on the common for the animals, as well as several inns for the drovers. None of these buildings have survived today. Cholesbury once had a much larger common. Like nearly all other common land, there has been a series of encroachments over the years. Commons with any industry were attractive to migrant workers – some of these squatted and stayed. Despite being fined for their encroachment, they were allowed to stay. The early seventeenth century saw a lot of this land grabbing activity in Cholesbury, and several houses around the common today are there as the result!

The mainstay of livelihoods was in the agricultural area, including many orchards where seasonal picking work was available. There was also the ubiquitous straw plaits and lace making in this useful cottage industry. Without a powerful source of running water, milling had to be done by windmill, and Cholesbury Mill, on the border of neighbouring Hawridge and Cholesbury, was used by both village communities.

OS Explorer Sheet 181 *Chiltern Hills North.*
Geological Sheet 238 *Aylesbury* 1:50,000.
Grid ref: SP 930 073 (hill fort, village centre).

Cholesbury hill fort.
(*Photograph by Hayley Watkins*)

Answers to Questions in Trail 9

People vary quite a bit depending on their background and which country their ancestors came from. However, if your ancestors have been in Britain for many generations, then your Iron Age 'roots' may have come down by word of mouth over more than 2,000 years. If your family has different origins then superstitions will be different, but similar to other people from that country.

1. Do you have a lucky number?
The Iron Age lucky numbers were 3, 5, 7, 9 and 17 for the odds, and 12 was the most important even number.

2. Have you ever thrown a coin in a fountain or pool?
This is a very important one. Quite probably most of us do this 'for charity' these days, but it originated as a much older custom. Look at a coin, it always has a head on it. The coin now is just a symbol of something rather sinister in the Iron Age. In those days, the 'head' would not be on the coin, but it would be the head of the enemy, the head of someone you had just killed in battle. If you think about this carefully, this token was very lucky as the head going into the well, river or pool was your enemy's head and not yours!

3. Have you danced, or watched, a maypole dance?
This is the Celtic celebration of spring and the dance would have been around a budding tree. We still do this in every village in May.

4. Do you do anything on Halloween (e.g. pumpkins or trick-or-treating)?
For the Iron Age people this was the 'holiday of the dead'. It was a very scary time when ghosts and bad spirits could come out to get you.

5. Do you have any superstitions about:
Black cats: Very lucky (although some people say unlucky! Collective memory has become jumbled here).
Magpies: Very revered birds because of their powers to bestow bad luck. In the Iron Age you would always acknowledge a magpie and say 'hello' or something nice if you saw only one (which would be bad luck). To see two or more is good luck. Many people still do this traditional acknowledgement. Do you know a song about magpies? It was used for a TV programme some years ago.
Spilled salt: Very unlucky to spill any, so if you do, you must throw a little over your left shoulder to keep the devil away.

There are so many more superstitions – and every single one has come directly down to us, by word of mouth, from the Iron Age.

Recommended Walks and Places to Visit

Bedfordshire

Dunstable Downs Chilterns Gateway Centre
Whipsnade Road, Dunstable, Beds, LU6 2GY
www.nationaltrust.org.uk

Pitstone Green Museum
Pitstone Green Farm, Vicarage Road, Pitstone, Leighton Buzzard, Beds, LU7 9EY
www.pitstonemuseum.co.uk

Priory House Heritage Centre
33 High Street South, Dunstable, Beds, LU6 3RZ
www.dunstable.gov.uk/priory-house/

Stockwood Discovery Centre
London Road, Luton, Beds, LU1 4LX
www.stockwooddiscoverycentre.co.uk

Wardown Park Museum
Old Bedford Road, Luton, Beds, LU2 7HA
www.wardownparkmuseum.com

Buckinghamshire

Amersham Museum
49 High Street, Amersham, Bucks, HP7 0DP
www.amershammuseum.org

Buckinghamshire County Museum
Church Street, Aylesbury, Bucks, HP20 2QP
www.buckscc.gov.uk

Chesham Museum
15 Market Square, Chesham, Bucks, HP5 1HG
www.cheshammuseum.org.uk

Chilterns Open Air Museum
Newland Park, Gorelands Lane, Chalfont St Giles, Bucks, HP8 4AB
www.coam.org.uk

Ford End Watermill
Station Road, Ivinghoe, Bucks, LU7 9EA
www.fordendwatermill.co.uk

Hughenden Manor
Hughenden Road, High Wycombe, Bucks, HP14 4LA
www.nationaltrust.org.uk

Lacy Green Windmill
Pink Road, Princes Risborough, Bucks, HP27 0PG
www.laceygreenwindmill.org.uk

Milton's Cottage Museum
21 Deanway, Chalfont St Giles, Bucks, HP11 1XS
www.miltonscottage.org

Pann Mill Watermill
The Rye, High Wycombe, Bucks, HP11 1XS
www.pannmill.org.uk

Roald Dahl Museum
81-83 High Street, Great Missenden, Bucks, HP16 0AL
Café Twit welcomes the public and museum visitors from 9am to 5pm, Tuesday to Saturday,
10am to 5pm on Sunday.
www.roalddahlmuseum.org

West Wycombe Park
West Wycombe, Bucks, HP14 3AJ
www.nationaltrust.org.uk

Wycombe Museum
Priory Avenue, High Wycombe, Bucks, HP13 6PX
www.wycombe.gov.uk

Hertfordshire

Ashridge Visitors Centre
Moneybury Hill, Berkhamsted, Herts, HP4 1LX
www.nationaltrust.org.uk

Hitchin Museum
Paynes Park, Hitchin, Herts, SG5 1EH
www.north-herts.gov.uk

Natural History Museum, Tring
Walter Rothschild Building, Akeman Street, Tring, Herts, HP23 6AP

Rebournbury Mill
Redbournbury Lane, Redbourne Road, St Albans, Herts, AL3 6RS
www.redbournmill.co.uk

Tring Local History Museum
The Market Place, Brook Street, Tring, Herts, HP23 5ED
www.tringlocalhistorymuseum.org.uk

Verulamium Museum
St Michael's Street, St Alban's, Herts, AL3 4SW
www.stalbansmuseums.org.uk

Oxfordshire

Ewelme Watercress Beds & Nature Reserve
High Street, Ewelme, Wallingford, Oxfordshire, OX10 6HQ (SU 641 918)
www.ewelmewatercressbeds.org and www.chilternsociety.org.uk/ewelme/about.php

Greys Court
Roterhfield Greys, Henley-on-Thames, Oxfordshire RG9 4PG
www.nationaltrust.org.uk

Earth Trust
Little Wittenham, Abingdon, Oxfordshire, OX14 4QZ
www.earthtrust.org.uk

River and Rowing Museum
Mill Meadows, Henley-on-Thames, Oxfordshire, RG9 1BF
www.rrm.co.uk

Thame Museum
79 High Street, Thame, Oxfordshire, OX9 3AE
www.thamemuseum.org

Wallingford Museum
Flint House, High Street, Wallingford, Oxfordshire, OX10 0DB
www.wallingfordmuseum.org.uk

Bibliography and Further Reading

Eyers, J., *Geological Walks in South Bucks* (High Wycombe: Rocks Afoot, 1998)

Gelling, M. and Cole, A. *The Landscape of Place-Names* (Stamford: Shaun Tyas, 2003)

Hepple, L. W. and Doggett, A. M., *The Chilterns.* (Sussex: Phillimore, 1992)

Lewis, M. D., *A Short History of Brick and Pottery Making in Nettlebed, Oxfordshire* (Unpubl. Manuscript, 2004)

Poulton-Smith, A., *Oxfordshire Place Names* (Amberley Publishing, 2009)

Toulmin Smith, L. (ed.), The Itinterary of John Leland in or About the Years 1535 to 1543

URL: http://www.archive.org/stream/itineraryofjohnl05lelauoft/itineraryofjohnl05lelauoft_djvu.txt (Accessed: 12 January 2014)

University of Nottingham, Key to English Place Names website. URL: http://kepn.nottingham.ac.uk/ (Accessed January, 2014)

Chilterns Information

Good information is available from these sources:

Atlas of Hill Forts in Britain and Ireland Project. For more information visit:
www.arch.ox.ac.uk/hill forts-atlas

BBOWT: Bucks, Berks and Oxfordshire Wildlife Trust
Oxford office and general enquiries:
The Lodge, 1 Armstrong Road, Littlemore, Oxford, OX4 4XT
Tel: 01865 775476; e-mail: info@bbowt.org.uk

Bucks Earth Heritage Group
A conservation group that looks after a number of sites in association with the site owners and managers. As well as the site conservation days the group run interesting walks, talks and other events, and also undertake research on the county's geology, as well as the nature that lives in and on it.
Mike Palmer, Bucks County Museum, Resource Centre, Halton, Bucks, HP22 5PN.
Tel: 01296 624519; www.bucksgeology.org.uk

Chiltern Archaeology
For public events, visits, talks and training alongside archaeological research.
13 Pusey Way, Lane End, Bucks, HP14 3LG
www.chilternarchaeology.com

Chiltern Society
White Hill Centre, White Hill, Chesham, Bucks, HP5 1AG
Tel: 01494 771250; Fax: 01494 793745; www.chilternsociety.org.uk

Chilterns Conservation Board
The Chilterns Area of Outstanding Natural Beauty (AONB) was designated in 1965 and covers 833 square kilometres, stretching from the River Thames in Oxfordshire to Hitchin in Hertfordshire. It is one of forty-six AONBs in the UK that, along with National Parks, are protected as the finest landscapes in the country.
 The Chilterns Conservation Board is the public body established in 2004 to conserve and enhance the Chilterns AONB. Its twenty-seven members are drawn from local communities and it has a staff team of eleven. To find out more about the Chilterns AONB, its history and

places to visit, go to www.chilternsaonb.org or write to The Lodge, 90 Station Road, Chinnor, Oxfordshire, OX39 4HA. Tel: 01844 355500.

College Lake (BBOWT)
Upper Icknield Way, Bulbourne, Tring, Herts, HP23 5QG
Tel: 01442 826774; email: collegelake@bbowt.org.uk

Jewsbury, Alison: jewsbury_alison@hotmail.com
For reconstructions or archaeological drawings and plans.

King, Stuart: www.stuartking.co.uk
This website contains a wealth of images and articles relating to the Chilterns, both historical and contemporary. The old local craft skills are particularly well represented.

A red kite. Since the reintroduction programme that began in 1989, red kites have become a common sight in the Chilterns. At this location, the author has seen as many as sixteen circling together, gaining height in the thermals at the edge of the escarpment. Their diet is very adaptable and, in the Chilterns, includes carrion such as rabbits, mice, rats, pigeons and crows, but occasional small mammals are taken as live prey. When seen swooping several times to grassy areas they are usually foraging for earthworms. (*Photograph by Hayley Watkins*)